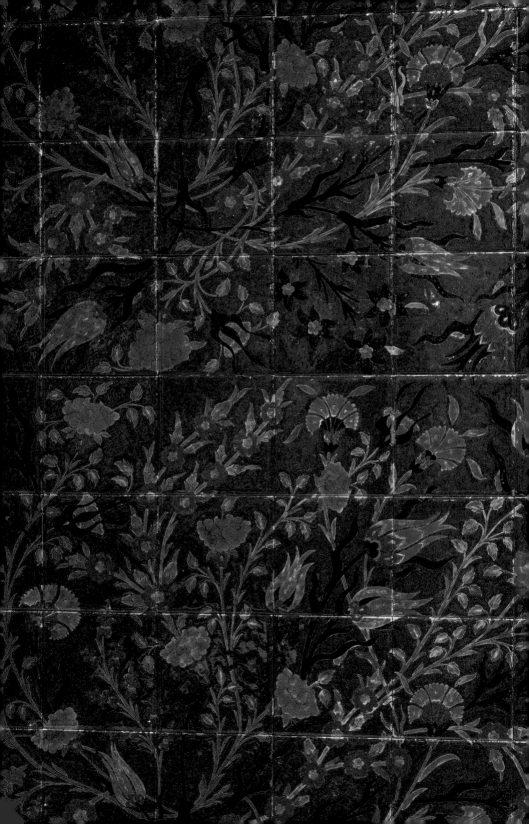

FRED WILSON AFRO KISMET

March 23 – April 28, 2018 6 Burlington Gardens London
July 10 – August 17, 2018 510 West 25th Street New York

PACE

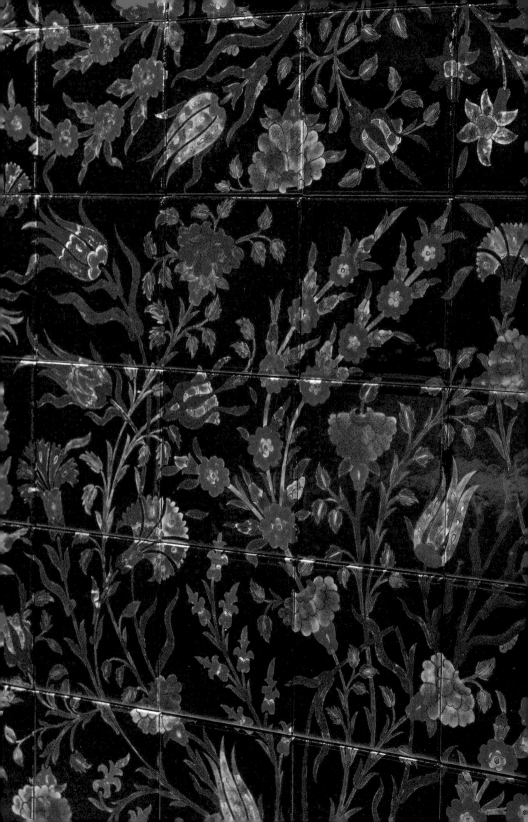

TABLE OF CONTENTS

Acknowledgements

Every exhibition we do at Pace has its demands and complexities; Fred Wilson's *Afro Kismet* however, might be in a category of its own. Thus, there are many people who need to be especially thanked. Originating in Istanbul at the Pera Museum, produced in Turkey and Venice by Fred in a matter of months and then traveling on to London, New York, and Charleston only begins to tell the story.

The works in this exhibition would never have come into being had Fred not been invited by Michael Elmgreen and Ingar Dragset to participate in the 15th Istanbul Biennial. Both Fred's American pavilion in 2003 and Elmgreen & Dragset's Danish and Nordic pavilions in 2009 were, for this longtime visitor to Venice, as expansive and generous as any ever. Michael and Ingar's introduction in the catalogue is equally generous as well as beautifully written (and not in their first, or even I believe their second language). As an admirer of their work, it has been an honor and a pleasure to get to know them and to now count them as friends. I know Fred feels the same way.

Bige Örer also needs to be thanked profusely on three fronts: as the unflappable Director of the Istanbul Biennial; as Fred's main contact and his interface with the Turkish fabricators and suppliers; and finally, as the Turkish voice in this catalogue. In the latter capacity, Bige wrote a text that managed to inform the artist himself of facts about and meanings in his work that were new to him. Having worked with Fred now for almost 15 years and knowing how exceptionally conscious he is, I can honestly vouch for how rare this is.

Darryl Pinckney has become in recent years one of the foremost writers on African American art. His simultaneously probing and sensitive interview with Fred gives us the artist's voice on this intricate body of work. Both Fred and I feel privileged by the introduction to this great writer and wonderful person, and for this we can thank my dear friend Lynn Nesbit, Darryl's agent.

The visionary support of Fred's work by the Denver Art Museum and its donors was instrumental in the realization of *Afro Kismet* in Istanbul. Rebecca Hart, the Vicki and Kent Logan Curator of Modern and Contemporary Art at DAM, acted on her admiration for Fred's work while still at the Detroit Institute of Art by acquiring *To Die Upon a Kiss* with her colleague Valerie Mercer and director Graham W. J. Beal. The acquisition of *The Way the Moon's in Love with the Dark* by the Denver Art Museum in the midst of this new body of work was a crucial vote of confidence in Fred and his work as well as in his continuing growth and evolution as an artist. This would not have been possible without the support of Christoph Heinrich, the Frederick and Jan Mayer Director of the Denver Art Museum, and the generosity of the museum's donors.

After London and New York, in late Spring, *Afro Kismet* will travel to the Gibbes Museum of Art in Charleston. The presentation by the Gibbes of *Afro Kismet* is particularly appropriate in conjunction with Spoleto Festival USA and their pending 2020 programming exploring the relationship between Islam and historic Charleston. This is an unbelievable confluence of events only Spoleto Festival Director Nigel Redden, with his wide-ranging interests, could have had the brilliance to bring about. Their convergence brings Fred to this most magically and tragically beautiful of American cities, a place long on his wish list to get to know. Gibbes Executive Director Angela D. Mack has been an enthusiastic and patient partner with the lagniappe of having Istanbul born parents.

The whole Pace team made this exhibition happen, but we need to give special mention to:

Paul Pollard and Tomo Makiura for this beautiful and complex catalogue produced during one of the busiest times in their always busy schedule.

James Sadek our Exhibition Manager, who, as always, went above and beyond assuring Fred that *Afro Kismet* could be reconfigured beautifully in all three sequential spaces after Istanbul.

Carlo Bella of Pace African and Oceanic Art, who found African sculptures appropriate to Istanbul and subsequent venues.

Tamara Corm, in London, for her enthusiastic response to *Afro Kismet* in Istanbul and her tireless search for works to replace those

from the Para Museum collection in the original exhibition. Our Technical Manager in London, Sebastian Humphrys, who managed the complicated logistics of bringing *Afro Kismet* to our London gallery.

And finally, the patience and hard work of Alex Brown and Lodewijck Kuijpers in my office and Nancy Rattenbury the Pace registrar with whom Fred worked to make all of this happen.

Lastly, of course none of this would have happened without the artist. After decades of groundbreaking work, Fred Wilson is continuing to challenge himself while inspiring us as viewers and urging us to question the status quo. Having known of Fred's work since first hearing about his groundbreaking *Mining the Museum* in 1993, his installation *Speak of Me as I Am* at the 50th Venice Biennale in 2003 came as a tour de force with its simultaneous beauty and humor while handling complex and sometimes dark histories with a remarkable depth and lightness of touch. Fred has brought the same approach to *Afro Kismet* and we at Pace are honored to have worked so closely with him on this brilliant exhibition.

—Douglas Baxter

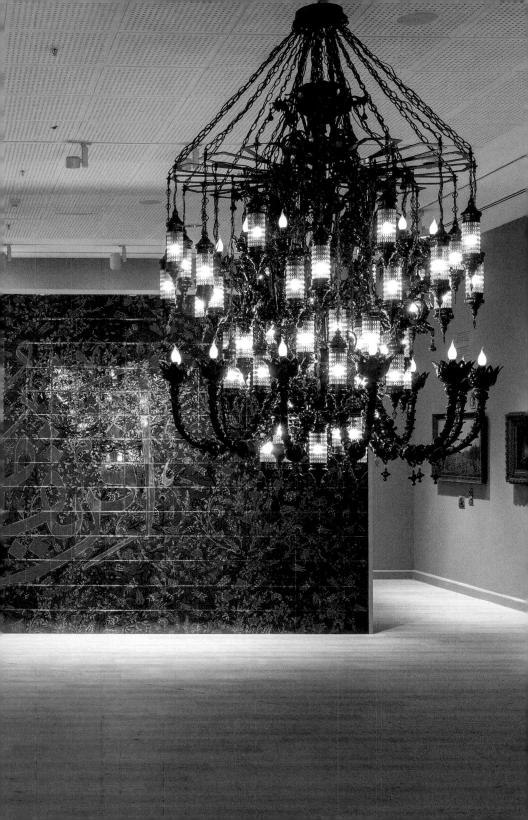

Fred Wilson—Our Neighbour in Istanbul

By Elmgreen & Dragset,
curators of the 15th Istanbul Biennial, 2017

We first met Fred Wilson after inviting him to participate in the 15th edition of the Istanbul Biennial that we had recently been appointed to curate. At that point, we had already chosen a title for the biennial: *a good neighbour*. With all letters in lowercase and the absence of a question mark, the title purposely had no clear statement and lacked cause or effect. It was a title chosen before the attempted coup in Turkey (on July 15, 2016) and its political aftermath, before Brexit, and before Trump became president of the United States (partly on the promise of building a wall on the Mexican border). Large global issues were at stake, and the needle of the power barometer tilted toward exclusion and isolationism, rather than collaboration and exchange. At a time when political problems and societal changes were looming so large they seemed ungraspable, we were hoping to bring politics *home*—back to its roots—to the *politics of our homes*. We were looking for the personal stories, believing that the microcosm often reflects the macrocosm, and vice versa. And with what some critics

have labeled "a feminist strategy," we set out to explore how our perception of home had changed over the past decades: how we protect, shelter, and express our identities within our domestic settings, but also how these private spheres (our homes) function next to one another. By naming the exhibition *a good neighbour*, we aimed to steer the focus away from home as dwelling and design and place it instead on the people who are living side by side—on the coexistence of diverse identities.

In one of his very early exhibitions, *Rooms With a View: The Struggle Between Culture, Content, and the Context of Art* (1987–88), shown at a former public school in the Bronx, Wilson had, as a curator himself, dealt with the domestic setting—the salon-like home museum—as a framework for his personal and complex visual history lessons. As artists, we have always felt an affinity with the way that Fred "superimposes" one kind of archetypal space onto another—for example, bringing a posh historical home décor into a former classroom in the Bronx or an ethnographic museum display into a white-cube space in Chelsea. This element of surprise *through displacement* alerts the viewer and makes it possible to introduce other notions of history rather than just the dominant one. Wilson's working method has been described as "juxtapositions of history and the present," but we have always felt that the extraordinary strength in his works is in the way they manage to show us that history is *in* the present, that our shared contemporary culture is *that* history. We are surrounded in our current-day reality by a history that has been written by the very few, whether it be in the artifacts selected for museum displays, in the history books, or in the news media's references to historic events. As artists,

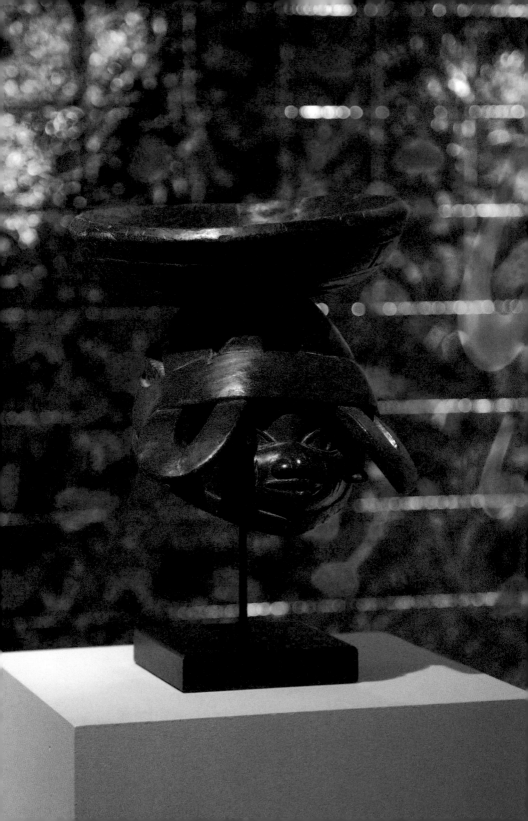

we can also easily relate to the way Fred draws the subject matter closer to the viewer by utilizing familiar, everyday objects. His carefully choreographed environments are inclusive because you, the viewer, get sucked into the storytelling, the magic of the objects, and you suddenly allow yourself to give your fearful respect of conceptual art a healthy break.

We were drawn to Wilson's practice in the context of the Istanbul Biennial also because it speaks to the feeling of belonging, or not belonging, of people and aspects of history that have been ignored, disrespected, or made invisible. And he is not satisfied with just pointing out the outrageous discrepancies within society and historical narration. With subtle means, he turns the presumed reality on its head and shows us the hidden, oppressive layers behind the polished facades of the well-meaning but sometimes ignorant institutional pillars of our societies.

We first experienced Wilson's work "live" in 2003, when he represented the United States at the 50th Venice Biennale with his groundbreaking exhibition *Speak of Me As I Am*—a title taken from a line from Shakespeare's *Othello*. Outside the US Pavilion in the heart of the Giardini area, a man of African origin was sitting on the ground, offering counterfeit versions of expensive Prada bags. The scene was (and, sadly, still is) a familiar one on the central tourist streets of Venice and many other Mediterranean cities, where migrants lacking residential rights and proper work permits are forced to seek more or less illegal ways to earn a living. Entering the pavilion, one passed between two large blackamoor figures seemingly holding up the portico above the neoclassical entrance. Such exoticized representations can be found in

18

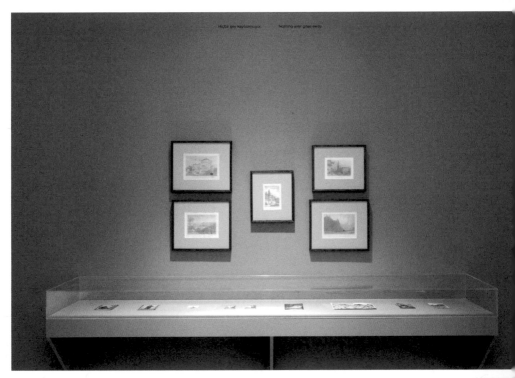

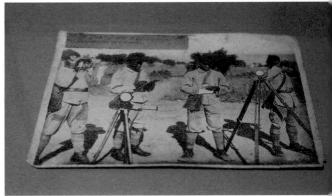

abundance at hotels, palazzos, and museums all over Venice. Wilson just recontextualized what was already to be seen everywhere. He made the invisible visible and made connections between a colonial past and its implications for contemporary life.

We did not tell Wilson the following anecdote, which stems from a dinner party in Venice in one of those palazzos that is still decorated with the same style of blackamoor figurines. One of the guests, a white British colleague of ours, told us that as kids she and her siblings used to be naked and painted black and made to stand and hold silver trays of delicacies as guests arrived at their parents' home for parties. This must have been in the 1970s. We all gagged in disbelief as she told us this. But Wilson has shown us that it might be necessary for such stories to come to the surface. We cannot hide from the past and pretend that everything is now good. Had it not been for artists and thinkers like him, many might still not have been able to see the outlandishness of our friend's childhood memory.

At our first meeting in New York, Wilson told us how—in the course of researching the historical presence of Africans in Venice—he had come across several parallels and connections between the Venetian and the Ottoman empires. This research material had not been included in the US Pavilion, but could make for a great starting point for his contribution to the Istanbul Biennial. Already, the facts he presented to us at our first meeting were rather astonishing. Trade between the two empires had been thriving in medieval times, in goods such as spices, silk, even ash for the coloring of glass. But the presence of black people in Venice and other places in Europe was mainly due to the trading

of slaves of African and Arab origin. We had no idea
that the great-grandfather of the Russian poet Pushkin
had been a black slave at the court of an Ottoman
sultan and was later passed on to Peter the Great.

Before breaking up the meeting in New York, we agreed
that it would be imperative for Wilson to visit Istanbul
as soon as possible, to continue his research there
and to see where this would lead him. It was to be his
first visit to Turkey. But then came an official warning
from the US government against traveling to Turkey,
and the trip was canceled at the last minute. Weeks
passed and we started to worry that Wilson would not
be able to visit at all. The US was calling embassy staff
home, and the warnings were to be taken seriously.
The security situation in Turkey was far from optimal,
and the Turkish government's actions were not exactly
promising calmer times ahead. The Turkish president's
behavior was getting increasingly irrational, to put it
mildly. Then, against all expectations, Donald Trump
was elected US president, and Wilson decided, despite
the warnings, to go on his first Istanbul visit anyway;
a country is not its president, and one place seemed to
be as mad as the other.

It was immediately clear that the Pera Museum was
the perfect place for Wilson to start his research in
Istanbul. It is a private museum in the center of the
city, with changing contemporary exhibitions on
the three upper levels, including a presentation of
Ottoman-era marine, trade, and culinary artifacts on
the first floor, and—most interestingly—a permanent
display of Ottoman paintings on the second. Unlike
many other visitors, Wilson observed that black people
were depicted in several of these paintings, often
in the background or on the peripheries. Some of

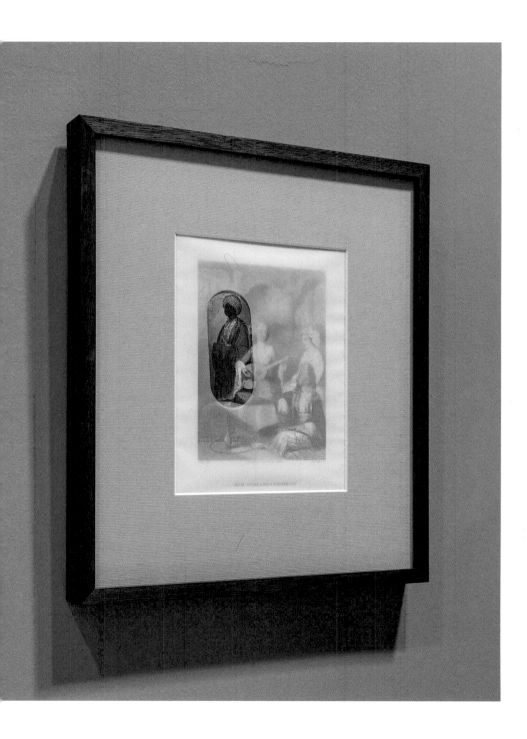

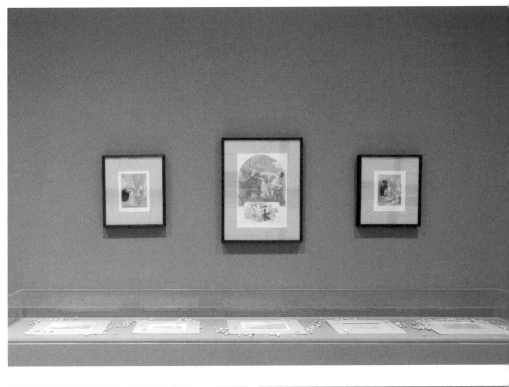

these paintings eventually made it into Wilson's final installation one floor up. Wilson also requested that the curatorial staff search for other paintings in the museum's storage that included African characters, but the staff could not find much material. Only after he insisted on taking a look himself did five more paintings come to light, which ended up being included in the final display. Each black figure (most were male) was photographed, printed in large format, and then placed next to the painting it was taken from, making him the main character. The material found at Pera was combined with paintings and artifacts from other collections throughout Istanbul, as well as with existing signature Wilson works, such as his black-and-white flag paintings and his ambiguous black glass oil drips/sperm cells/tears.

Wilson also went around to thrift stores and antique shops to find old etchings and prints, which displayed—more often than not—a sole black person among Turks and Europeans. The artist put a layer of translucent white matte paper on top of these prints, and made a cutout just big enough to reveal the one black character's head as the only remaining visual information. It was an aesthetic alteration of the image that he had previously used in exhibitions such as *To the Rescue: Eight Artists in an Archive* (1999). The effect is a sort of personalization through decontextualization. Wilson has spoken of the loneliness he finds reflected in himself when looking at these isolated people of color on prints and paintings he encounters.

This feeling was probably not any less strong after he spent several weeks in Istanbul, spread over seven trips from New York. Today there is not much

African representation in Turkey, not even in a big, international metropolis such as Istanbul. The Afro Turks who descended from Ottoman-era Africans are hardly visible in the urban landscape. But through his large-scale project, Wilson made numerous connections to the city, to scholars, to artists, to artisans, to vendors, and to writers. He made himself belong, on many different levels.

That seems to be the essence of Wilson's methodology, to question the normative written history. He is mining a museum, a culture, a city—be it Baltimore, Venice, or Istanbul—in order to find the precious ores that can be used productively in the fluid construct that is identity. Once these ores have been extracted, one can start to understand the complexities of one's past, of one's history, which is often tainted with more pain than pleasure. It is a way of finding a home in a world that sometimes seems to want to alienate anyone that is not from the dominant culture. Witnessing this ability to unearth the past and claim it as one's own is empowering and shows all of us that change is possible.

We realized early on that inviting Fred Wilson to an exhibition is like curating an artist *and* a curator. As artist-curators ourselves, this was a gift. We are already a collaborative team and will always welcome more collaboration. In the end, Wilson built up his own museum within a museum within a biennial, bracketed by two exquisitely hand-painted traditional Iznik tile walls, on which "Mother Africa" and "Black Is Beautiful" was written in Arabic lettering. Here again, several historical strata were exposed within one setting.

The two chandeliers that Wilson produced for the Istanbul Biennial are another example of neighborly

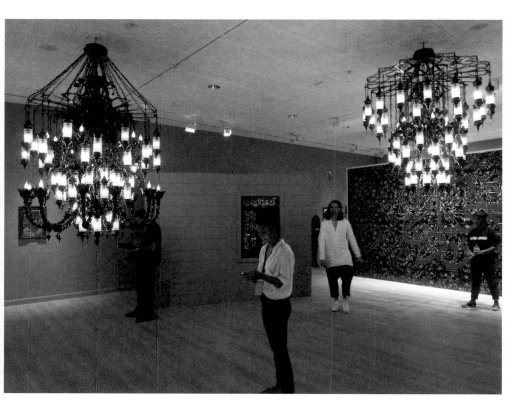

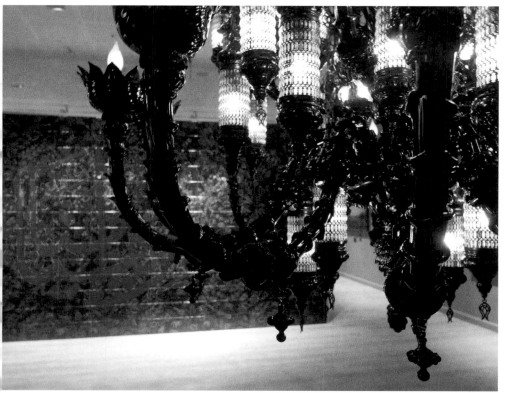

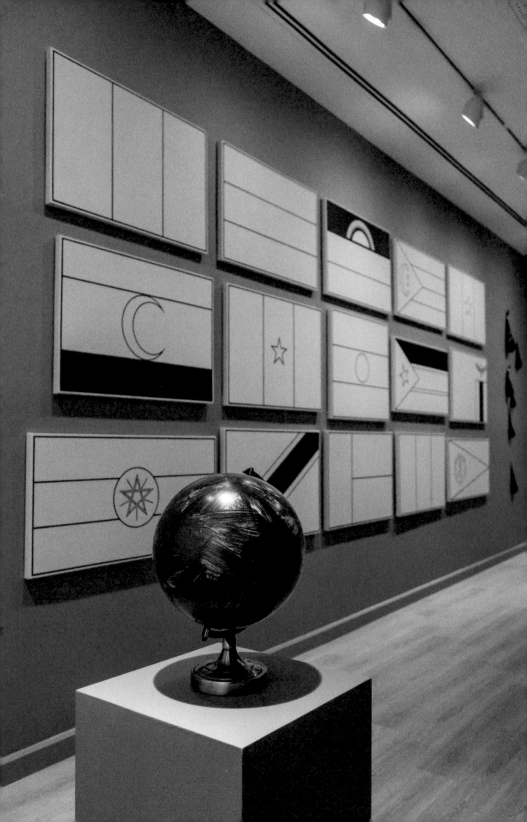

reconciliation, bringing together different histories and materials as well as artisanal skills, in this case from Istanbul and Venice. It took months of communication and collaboration between Wilson and metal workers and glassblowers in the two cities to create these grand fixtures. In addition to the symbolism typical of Wilson's chandeliers, with the black crystals diffusing the light source, here he brought together traditional design items iconic to different religions, creating new hybrid relics.

On the surface, Wilson's installations are often classically beautiful. He's not afraid of using easily recognizable or even visually seductive elements, only to collapse their meaning in confrontation with one another. His exquisitely executed settings lure you in, but there is always something disconcerting lurking under the surface. They might seem homely, but in truth they can be—to use a German term—*unheimlich*, which translates as "uncanny," or disturbing.

With his immense installation at the Pera Museum, Wilson turned out to be exactly the kind of neighbor we were hoping for. When we invited him to participate in the 15th Istanbul Biennial, he quickly revealed himself to be someone who can feel at home in almost any context. Wilson is someone who immerses himself in a situation with a lot of dedication but without much ado. He is someone who tells you that it is not necessary to complicate things further—because what is already there is complicated enough.

The aims of the dreamer, after all, is merely to go on dreaming and not to be molested by the world. His dreams are his protection against the world. But the aims of life are antithetical to those of the dreamer, and the teeth of the world are sharp.

Sonuçta düşler dünyasında yaşayanın tek amacı vardır, düşlerinde yaşamak ve dış dünyanın onu rahatsız etmemesi. Düşleri onun dünyaya karşı savunmasıdır. Ne var ki yaşamın amacı ve hedefleri düşlerde yaşayanın tam tersidir ve dünyanın dişleri acımasız ve keskindir.

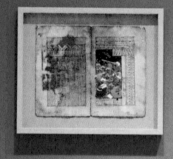

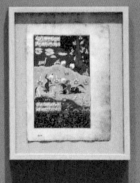

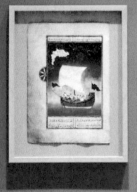

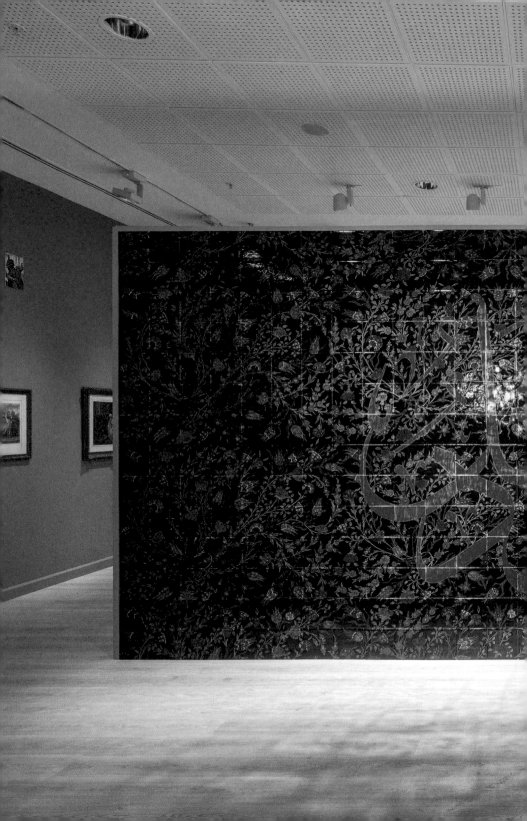

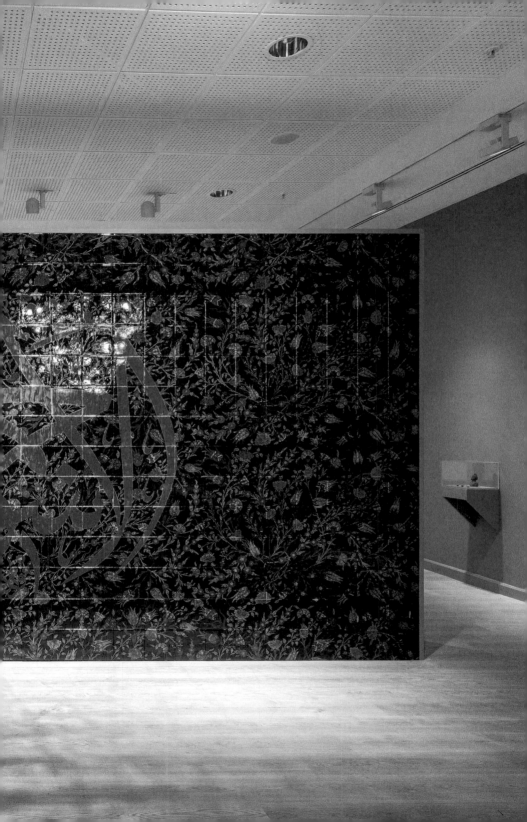

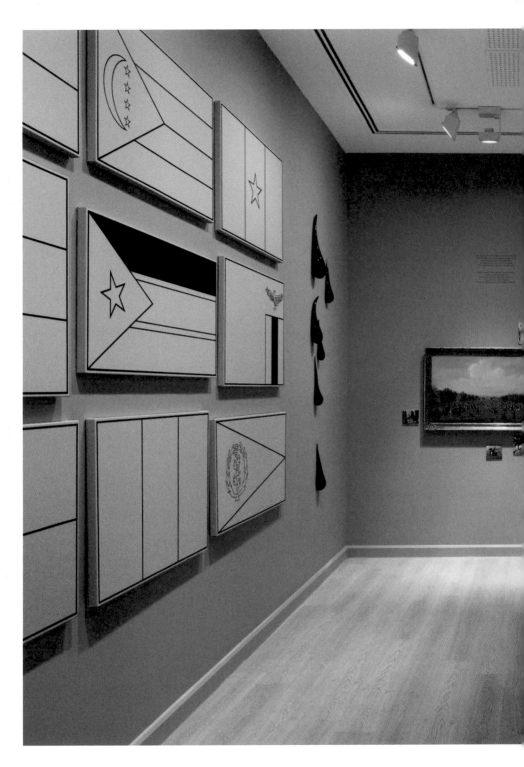

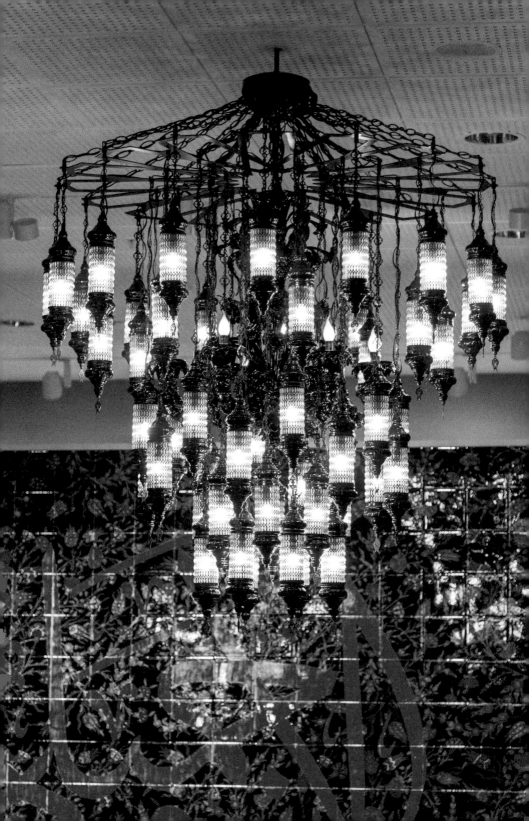

Afro Kismet

By Bige Örer
Director, Istanbul Biennial

> It is like Pandora's box—if you don't
> know, you don't know, but once you have
> been told, you can't close the box.
> —Fred Wilson

For thirty years, Fred Wilson has placed black history
at the center of his artistic practice; it is a history that
was untold for centuries, was neglected completely,
and was treated as if it was not even worthy of
consideration. "The work of Fred Wilson considers
the politics of inclusion, exclusion, and erasure in
the context of global cultural histories. This involves
a questioning of the conventions of display within
museums, as well as the notions of race that go
unexplored within cultural, economic, and artistic
accounts."[1] In an interview with Kathleen Goncharov,
Wilson says, "I am acutely aware of people's racial
blind spots, but I am most interested in people who
are marginal or invisible to the majority, and the
larger society's denial of certain issues. That goes way
beyond race."[2]

In autumn 2017, within the scope of the 15th Istanbul
Biennial, Wilson realized a large-scale installation
titled *Afro Kismet*, which spread out across the third

floor of the Pera Museum. Titled *a good neighbour*, and curated by the artist duo Elmgreen & Dragset, the biennial invited the viewer to think about coexistence in the same society with different identities. Wilson produced his work after an intense period of research, placing the work on a platform that brought different sources of information and inspiration onto the same field of thought. Wilson's research aimed to discover how blacks lived in these lands, from the time of the Ottoman Empire to the Republic of Turkey, both from a historical and a current perspective. From the beginning of his research, he was very interested in Istanbul's position in the long, and not-yet-completely revealed history of the Ottomans' relationships with people of black African descent. Wilson tried to understand how African-descended citizens of Turkey related to their past. In his meetings with researchers and journalists in this field, he observed that these topics still constituted a veritable Pandora's box. "Archaeological research" in museum collections is a characteristic of Wilson's practice, one he continued in Istanbul, where he visited many museums in order to see where, how, and how much the visual images of blacks were included in these collections. He was inspired by world literature from Shakespeare to Pushkin to Baldwin, and he also investigated how African characters appeared in the literature and visual and performance arts of Turkey. Throughout the research, he both sustained the methodology he applied in previous works and allowed the formation of hybrid structures: This constitutes a significant turning point in Wilson's practice. What emerged from this research was an installation made up of many parts that not only operated singularly, but also came together to shape an integrated installation.

From Baltimore to Cairo, Venice, and Istanbul

> When you shall these unlucky deeds relate,
> Speak of me as I am; nothing extenuate,
> Nor set down aught in malice.
>
> —William Shakespeare,
> *Othello, the Moor of*
> *Venice*, act 5, scene 2

Wilson combined his education in art with experiences growing up in his native New York. An artist, educator, and black viewer, in 1992 he held his first museum exhibition at the Maryland Historical Society in Baltimore. The show, *Mining the Museum*, "tells the story of the blind spots in the collection, the exclusions and inclusions that persist in the museum to this day because of collecting and exhibition patterns that have remained relatively constant since 1844."[3] With this groundbreaking exhibition, Wilson introduced to the attention of the art world research concerning the formation of museum collections and what is and is not visible in such collections. The museum's collection, and the narrative and formal presentation of that collection, had been shaped as if the history of black and Native Americans did not exist. Throughout his artistic process, Wilson continued to hold a mirror to museums in order to force them to face themselves. He confronted the unconscious racist references in exhibition methods, thus enabling cultural institutions to produce from the inside self-criticism of the narratives they have historically presented. For the Baltimore exhibition, Wilson found objects in the collection that for a long time had not seen the light of day. Working on the presentation in the museum of these objects alongside the Historical Society's treasures,

Wilson had enabled the population of Baltimore, which is 75 percent African American, to relate to the project and find something about themselves in institutions where they often felt excluded.

Wilson participated in the 4th International Cairo Biennale in 1992–93 with a work titled *Re: Claiming Egypt*, "a project that was mostly about the West's view of Egypt, the European view and the American view and the African American view of Egypt historically."[4] This project was important to him not only because he had lived there briefly with his father and has traveled there extensively, but also because it created his connection with this part of the world, unfolding the context of black people living in that region.

In 2003, Wilson became the second African American artist invited to represent the United States at the US Pavilion at the Venice Biennale, which opened in 1930. The first African American to represent the US was Robert Colescott, who only six years earlier had held a solo exhibition there.[5] In his research on the story and role in social life of black people in Venice since the Renaissance, Wilson followed Othello, one of Shakespeare's best-known characters. Despite his military success and intelligence, Othello is constantly made to feel like an "other" because of the color of his skin. When he is described as "black" by other characters, reference is made not only to the color of his face, but also to symbols of color: the honor and innocence of white, the sinfulness and criminality of black. This is a significant example of the prejudice that continued for centuries in European civilization, and the experiences of blacks during this process.[6]

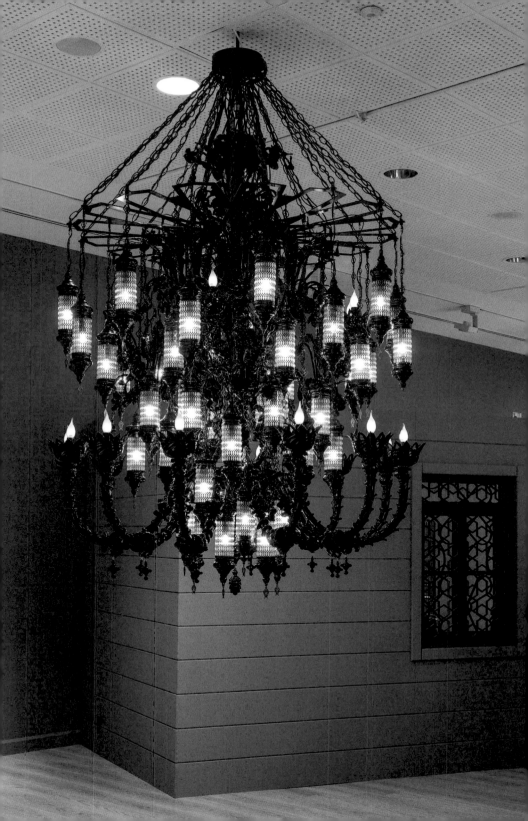

Wilson addressed the racial, ethnic, and cultural issues historically and created a mixed-media installation, consisting of a black-and-white tiled room containing graffiti from texts of African American slave narratives, black sculptures produced by glassblowers in Murano (in Venice), a faux museum display, reassembled sculptures, audio emanating from historical paintings, objects in vitrines with cogent labels, and a video of *Othello* projected backward. He was also aiming to connect the historical Africans with the present-day Africans in Venice.

When Wilson began his research for his work for the 15th Istanbul Biennial, he aimed to form a triangle with his works between Cairo and Venice, as part of his whole production. During the time of the Ottoman Empire, Cairo was one of the centers of the slave trade. Due to the restricted nature of the resources he could access ("No written documents, biographies, or autobiographies of Blacks living in Venice"),[7] Wilson could not find satisfactory answers to the questions he asked in Venice, so when he came to Istanbul to begin his research, he announced that he wanted to conduct interviews for the story of blacks on these lands and gather information both from historical and contemporary perspectives. He also shared his excitement about producing a new work that related to the title *a good neighbour*: "I was always looking for different stories. They are so tangential, seemingly inconsequential in relationship to other larger issues, but it is fascinating to tease things out."[8]

During the production process Wilson drew on many sources, and by interviewing academics, historians, journalists, citizens, and people of African descent, he collected information on the lives of blacks on these

lands and on their hidden realities. These interviews, which he conducted with the dream of combining his research spanning a quarter of a century with the local context, enabled him to realize a process of thinking and producing in collaboration with researchers and masters of various crafts. Wilson's magnificent instinct also played an important role in deciding on the details of the installation, one made up of many layers, inspiring many alternative readings. Placing issues such as the deconstruction of official history and institutional critique at the center of his artistic practice, he invited the viewer to focus on the history of slavery in Turkey and the relationship of the population of African descent in Turkey with the past.

Slavery in the Ottoman Empire, Blacks in Turkey

In stark contrast to what some believe in Turkey, slavery did exist in the Ottoman Empire. Ehud R. Toledano, who continues his significant research in the field, explains the historical process: "From the rise of the Ottoman state in the thirteenth century, slavery was familiar to and widely accepted by people in all walks of Ottoman life.... In the Ottoman Empire, military-administrative servitude, better known as the *kul* system, coexisted with other types of slavery: harem, domestic, and agricultural (on a rather limited scale)."[9] However, Toledano states that the Ottoman system of slavery was different from Western and non-Western systems. In terms of domestic slavery, it was unlikely for the master-slave relationship to assume the rigid and aggressive character found, for instance, on a US plantation. And there was also a mechanism that allowed slaves to be freed, thus setting it apart from other systems.[10] Nevertheless, the abolition of slavery,

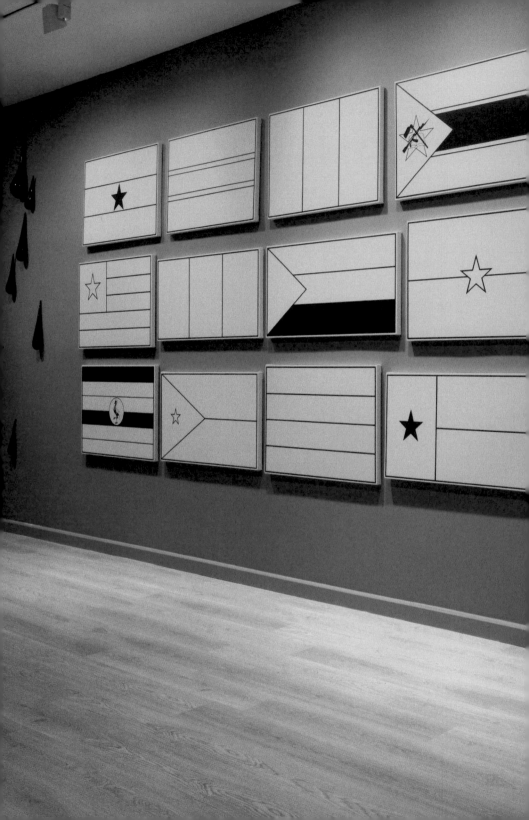

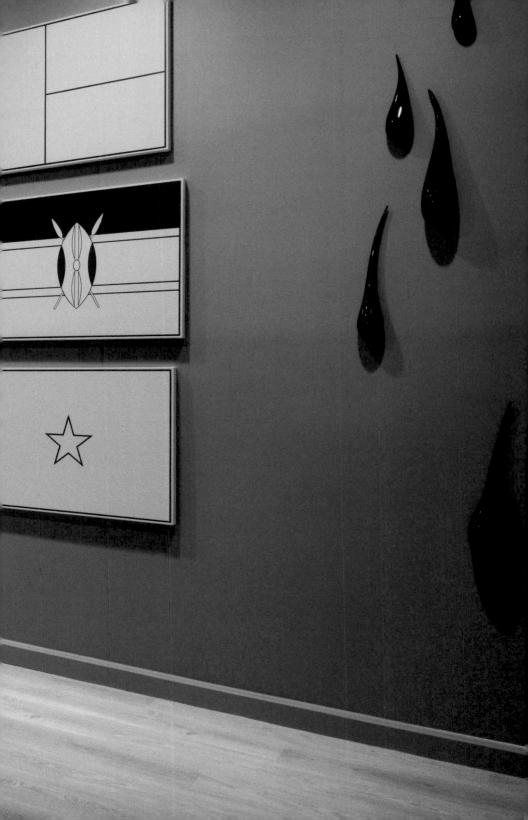

he writes, did not come easy: "Excepting the issue of equality for non-Muslims, the call for the abolition of Ottoman slavery was perhaps the most culturally loaded and sensitive topic processed in the Tanzimat period. Although it was rarely debated in public, this was a matter of daily and personal concern, for both the public and private spheres of elite life were permeated by slaves at all levels."[11]

Hakan Erdem explains slavery in the Ottoman Empire with the "open slavery" system, stating that there was no specific social class of hereditary slavery in the Ottoman Empire, and that there were slaves from around twenty different ethnicities in the nineteenth century. Not only are there very few studies on black slaves in Turkey, but also the educational system shares almost no information on slavery during the Ottoman period or about the "complete prohibition of the slave trade from Africa in 1857."[12] Even the use of the correct terminology, or a confrontation of this past, requires time and effort.[13] Wilson's interest in this field rendered issues that take place on these lands but are neglected—such as slavery, exploitation, and human mobility— into parts of the multi-layered structure of the work, inviting the viewer to think about this history.

Yıldız Yılmaz, who is working on her PhD at Boğaziçi University on black slaves in the Ottoman Empire (specifically on chief black eunuchs, who guarded the imperial harem), stresses the importance of exhibiting Wilson's works in Istanbul "since they concretely present, for the first time, the fact that we do not possess any knowledge on slavery, on blackness, on people who not a very long time ago lived with us, and have since melted away in time, and because they make us think what we have not thought about."[14]

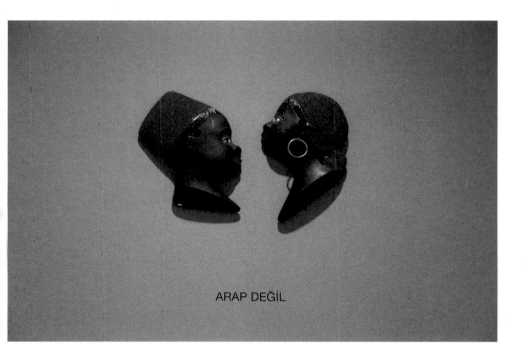

ARAP DEĞİL

Gürel Tüzün, whom Wilson met while researching, is also the general coordinator of *Voices of a Silent Past: An Oral History Project on the Past and Present Being "Afro-Turk,"* which aimed to record the experiences of citizens of African descent in Turkey in order to render them visible. Tüzün finds Wilson's work interesting because it underlines the importance of multiple narratives in history and reminds us that it is necessary to look at the same event from different perspectives. He believes that with the experimental method Wilson applies to museum collections and presentations, important discussions can be initiated for groups that live together in the same society and share a traumatic history (all minority groups in Turkey, and foremost Kurds, Armenians, and Greeks).[15]

Wilson also met with journalist Alev Karakartal and a group of her friends from Istanbul's black community. Karakartal remembers how "blacks both in the United States and Turkey constantly revolve around concepts

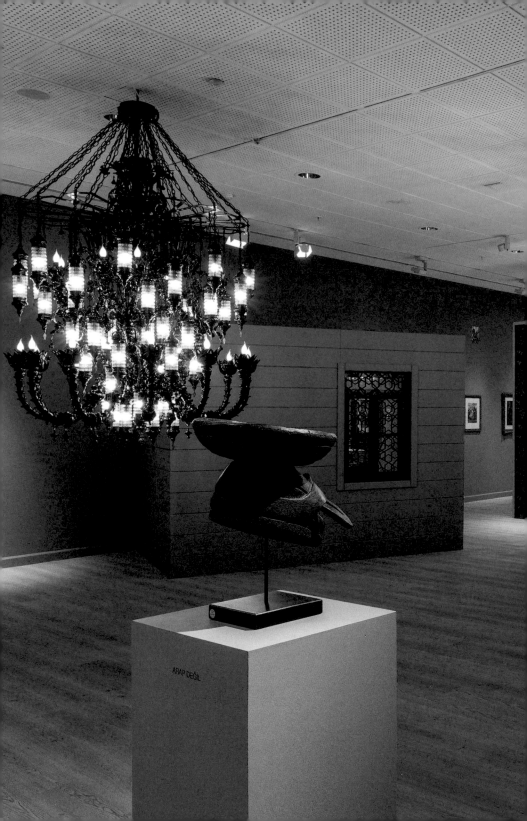

ARAP DEĞIL

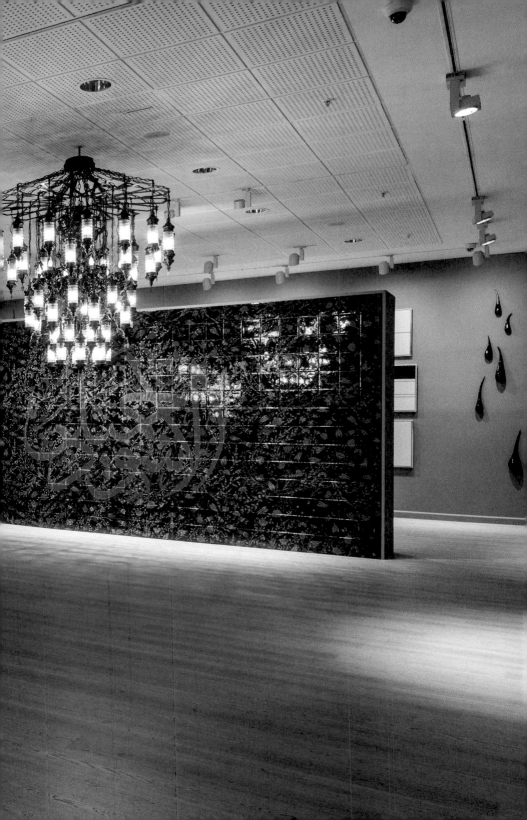

such as solitude/exclusion, silence, and to pale one's
skin color and therefore one's self, to erase one's color,
and even seek to assume that it does not exist, [which]
leads to sentiments of both familiarity and surprise
since it once again emphasizes the shared/similar
experiences of the African diaspora."[16]

Afro Kismet at the Pera Museum

In his installation *Afro Kismet*, Wilson included
various objects related to Ottoman culture and the
role blacks play in it. From a micro to macro level, he
displaced what is accepted as the secondary in the
center, successfully altering the viewer's perception.
At the entrance to the installation, the work creates
a luxurious combination of two Ottoman chandeliers
with two large Venetian baroque chandeliers made,
unusually, in black glass by a craftsman from a
centuries-old family of glassmakers in Venice. These
chandeliers evoke the contrast between the fate of
Africans and European empires. These objects, formed
by the unexpected combination of two different
forms, do not appear alien to each other; black brings
them together. Not only do these black chandeliers
illuminate the space, they also evoked the Turkish
phrase *gündüz feneri*, or "daytime torch," a term
used to describe a black person, a meaning that also
serves to mark a person as an "other." Karakartal also
reminded Wilson of this term, which she interprets as
a way of humiliating and excluding black people from
the rest of the society. Wilson also created ceramic
panels with a black background, and by changing the
white background that for centuries has determined
our perception, radically challenged an established
aesthetic structure.

Wilson also collaborated with the İznik Çini [Tile] Foundation, an institution that seeks to continue the Turkish art of çini and ceramics, which goes back to the Uyghur civilization of the eighth and ninth centuries, and produced two panels of İznik çinis. Integrated into a traditional floral design, these çini panels were rendered in a dark palette, with the background close to an eggplant-purple and black, an uncommon choice for tiles. On the tiles Wilson wrote the phrases "Black Is Beautiful" and "Mother Africa," in Arabic calligraphy, thus including the relationship between language and aesthetics in this project. While "Black Is Beautiful" refers to the cultural movement initiated in the 1960s by African Americans, "Mother Africa" points toward the continent black people came from. For the writing, Wilson worked with Ferhat Kurlu, one of the most important masters of *hat* (calligraphy). The text "Arap Değil" ("Not Arab"), next to two African wall statuettes, once often seen on the living room walls of middle-class families in large cities, aimed to render visible an often negative connection in a country where black people are often referred to as Arabs. Wilson also followed the traces of blacks in examples of the Ottoman art of miniature, an art form that reflected Ottoman palace culture and adorned luxurious items, like manuscripts. And in collaboration with master miniature painter Özcan Özcan, he prepared new works that brought together elements from different, existing miniature works. Wilson wanted the skin color in the miniatures to be close to black, and said he perceived miniatures as dreams, adding, "I wanted these characters to be Africans, and I wanted to think about their dreams. Was anyone thinking they could get out of this system, dreaming that they could be free? One of these boats, here in the miniature, is going across the water, away from Constantinople, kind of escaping—was anyone

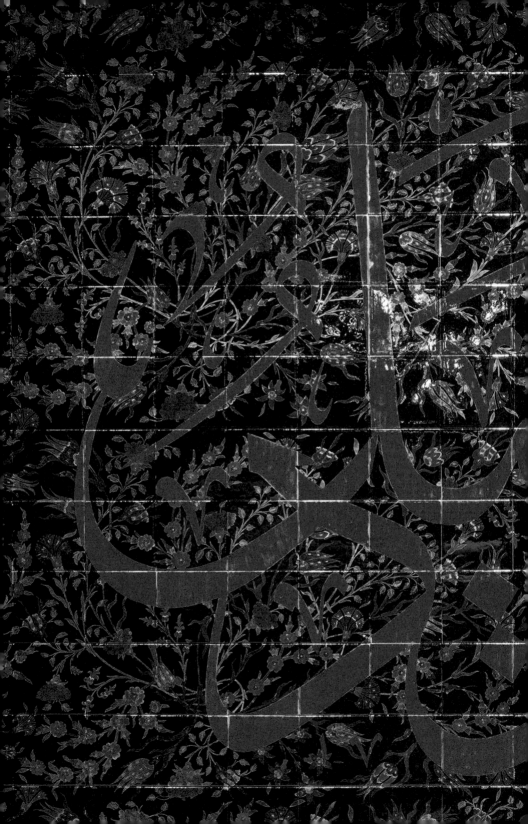

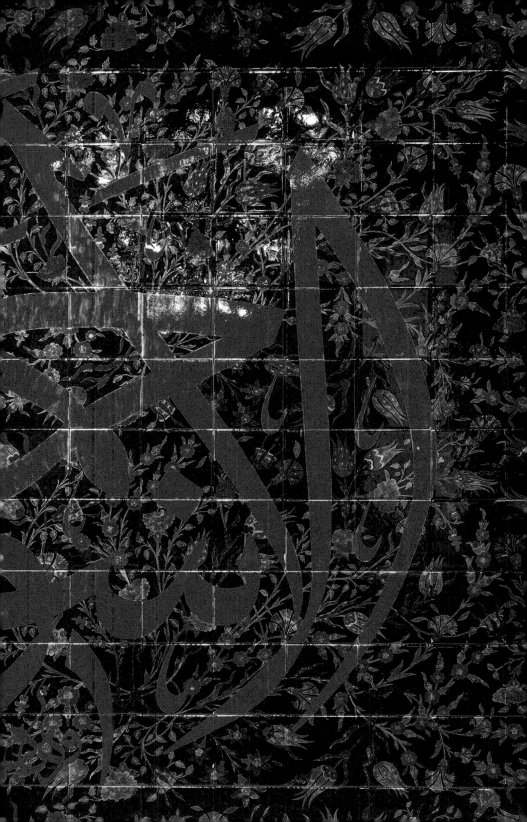

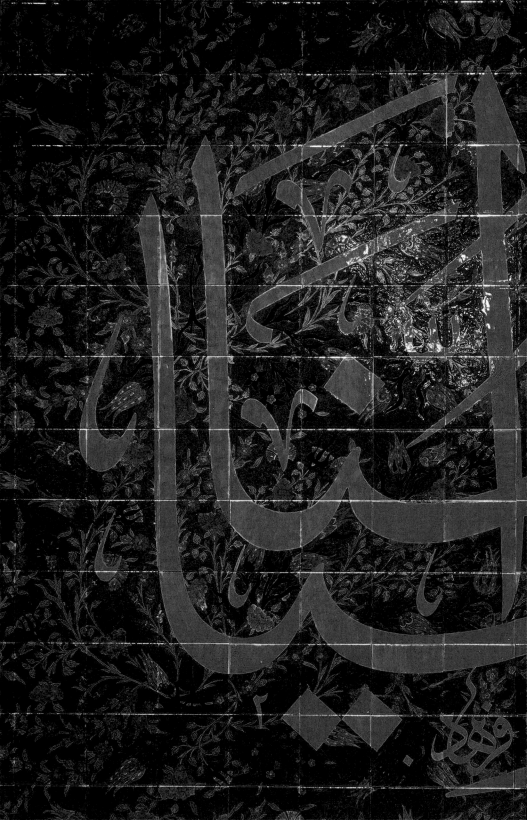

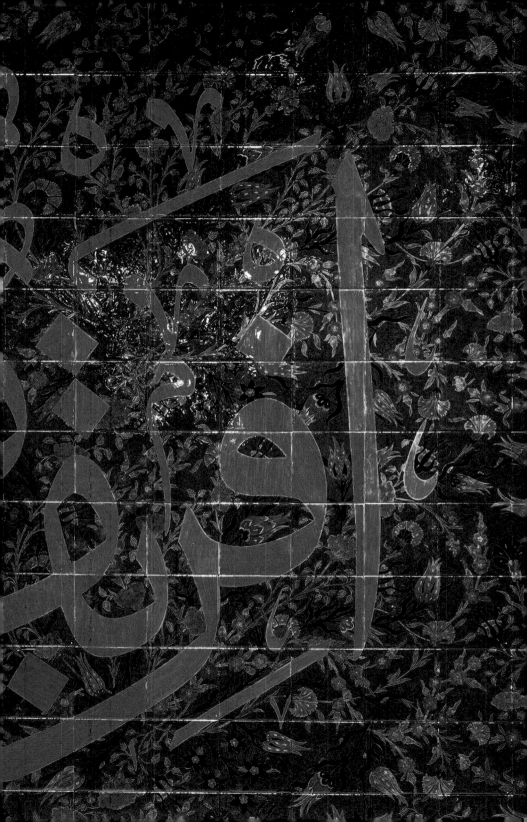

thinking that they could be free, that they would be in this boat?"[17]

There were also valuable historical paintings Wilson borrowed from different museums. With the permission of the Pera Museum, an oil painting that is normally exhibited at the collection floor, *A Scene from the Turkish Harem* (Franz Hermann, Hans Gemminger, Valentin Mueller, 1654) was displayed as part of Wilson's installation for the duration of the biennial. This painting is "considered to have significant value as a document, as it describes the Ottoman Harem, and features a date. The composition is divided into two parts; in the lower part the themes of meeting guests and dance have been depicted, while in the upper part, dancing women are depicted with their headgear and embroidered scarves in their hands, accompanied by musicians playing the instruments *rebab*, *def* and *santur*."[18] Among the musicians, a black woman plays the *def*. In the themes of orientalist painters, who depicted urban life in the nineteenth century—from the game of *cirit* held in Kağıthane (a recreation spot much in favor in Istanbul) to the Grand Bazaar and the Silk Bazaar to whirling dervishes—it is possible to see the position of blacks in society, in zones highlighted by Wilson.[19] In all these paintings, you can find an African somewhere on the periphery. Wilson was curious about who these characters were, what they did, and what kind of lives they led. He wanted the viewer to notice these characters as well and to draw one's attention to the African characters in all the paintings he or she looked at from then on.

Wilson's paintings of flags that have lost their colors, and are composed of black lines, forms, and symbols on a tan canvas, question once again what it means to be black and how the concept of a flag can represent a country.

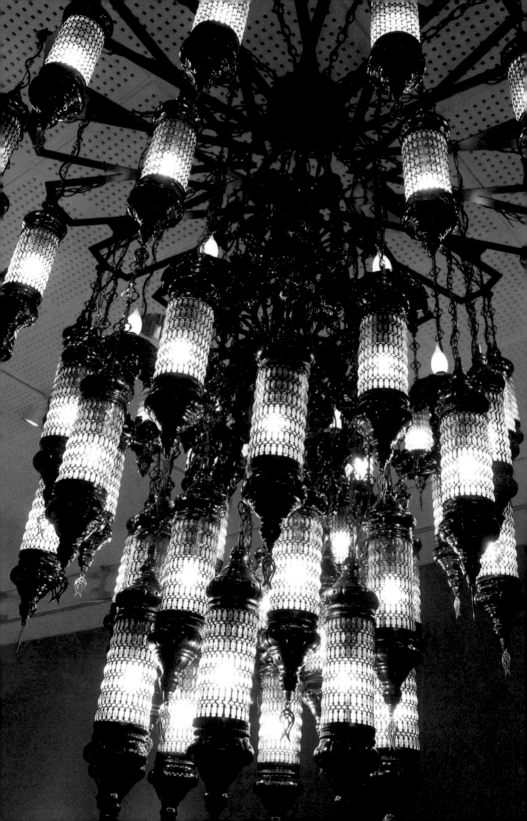

The blown glass sculptures right beside the flag paintings, with their striking structure, are reminiscent of black teardrops. They also evoke the qualities of different materials, including oil, tar, ink, and sperm, and come to symbolize being African.

Wilson's work brings together a great variety of objects and references, so one could read the work on many different levels. Historical photographs, engravings, and oil paintings; contemporary acrylic paintings and miniatures; a late-nineteenth-century *Othello* poster; an anthropomorphic terracotta flask from the third century BC; glass pendants from the fifth century BC; contemporary İznik tile panels; a carpet; chandelier sculptures, a globe sculpture and blown glass sculptures; a mid-twentieth-century wooden African mask and late-twentieth-century African figures; a wooden false wall; a birdcage; an antique chair and table; wall vinyl; and mounted photo scans and cowrie shells. All of these form parts of this universe of many depths. Wilson, in a sense, constructs his own museum within the exhibition space and acts as curator of items he has either produced himself or gathered from different places. He prepares the captions or introductory information for his works himself and meticulously selects his references.

Wilson has been called a "Foucauldian archaeologist" and a "conceptual materialist," who has engaged in "unearthing objects that reveal hidden histories and, more importantly, the internal workings and ideological paradigms of archives and museum collections."[20] Although Wilson's main thrust is based on a loaded and painful history, it does not contain any damaging anger at all. He does not construct his works in a confrontational manner; he wants viewers to think and

ask questions about their experience in the exhibition space; he wants to create an awareness. He calls upon viewers to remember the past, not to ignore or neglect it, and to recognize elements of racist discourse that have permeated everyday life and language. He invites the international viewer to think again about race, identity, history, society, and culture, and to consider multiple historical narratives and discourses.

A Journey to James Baldwin's Istanbul

> If you know whence you came, there is really no limit to where you can go.
> —James Baldwin, *The Fire Next Time*

> We all commit our crimes. The thing is to not lie about them—to try to understand what you have done, why you have done it. That way, you can begin to forgive yourself. That's very important. If you don't forgive yourself, you'll never be able to forgive anybody else and you'll go on committing the same crimes forever.
> —James Baldwin, *Another Country*

James Baldwin, who from 1961 to 1971 lived on and off in Istanbul, saw the city as a refuge; he completed his novel *Another Country* there and directed John Herbert's play *Fortune and Men's Eyes* at the Gülriz Sururi-Engin Cezzar Theatre to great acclaim. Having developed deep friendships with intellectuals and artists, Baldwin found Istanbul to be a place where he could objectively observe the civil-rights movement in the United States. In the short film *Off-White Tulips* (2013), Aykan Safoğlu has an imaginary conversation with Baldwin and says: "While you were thinking of ways to tell the whites about the history of their

country [the US] they had forgotten, you were in the
largest city of another country that had slowly started
to forget its history." Sedat Pakay's documentary
James Baldwin From Another Place (1970) focuses
on the time the writer spent in Istanbul and provides
important clues regarding his relationship with the
city he considered his second home. In her work about
how Baldwin's time in Istanbul contributed to his
artistic and literary accomplishments, Magdalena J.
Zaborowska writes, "Baldwin's Turkish decade [was]
a kind of voluntary exile, a temporal and a spatial
process of artistic incubation and discovery that
resulted in new ways of seeing and conceptualizing
(African) Americanness across the Atlantic."[21]

Wilson summons James Baldwin's story as the
inspiring spirit of the exhibition, and in this way,
enables the viewer to approach the US civil rights
struggle from a historical perspective, and as Baldwin
said of his time in Turkey, opens a passage leading to
Baldwin's "key artistic and political concerns on the
interdependence of race and the erotic in constructions
of American identity."[22] By including quotes from
Baldwin's *Another Country* in the installation, Wilson
aims to integrate with art the relationship he forms
with literature and history.

In Place of an Epilogue, Esmeray Sings a Children's Song

Finally, Wilson listens to a song in his Brooklyn studio:
a single titled "13,5" performed by Esmeray, one of
the most famous musicians in Turkey in the 1970s
(her name literally means "dark-skinned moon"),[23]
representing the melancholic, yet equally joyful sound
of the citizens of African descent in Turkey (she had
added her own sentiments to the lyrics to a children's
song by Sanar Yurdatapan):

13,5
It's raining, it's flooding
The Arab girl is looking out the window

It's me, the Arab girl,
Curly hair, red lips
Beady eyes, and a line of pearl teeth
A black fate written across my forehead

Kids run with fear when I appear
A pinch, 13,5
I don't mind my color being black
As long as my heart isn't

Dear mother, I fear, the goblin is here
If not the goblin, then it is the Arab Sister
the sister has no right to live comfortably
the sister has no right to carry a heart

It's raining, it's flooding
The Arab girl is looking out the window

Kids run with fear when I appear
A pinch, 13,5
I don't mind my color being black
As long as my heart isn't

Endnotes

1 Pablo Larios, "Fred Wilson," in *a good neighbour: 15th Istanbul Biennial,* eds. Ömer Albayrak, Anita Iannacchione, Sofie Krogh Christensen, and Erim Şerifoğlu, exh. cat. (Istanbul: Istanbul Foundation for Culture and Arts, 2017), 365.

2 Fred Wilson, interview by Kathleen Goncharov, *Fred Wilson: A Critical Reader,* ed. Doro Globus (London: Ridinghouse, 2011), 181.

3 Simon Dumenco, "Lost and Found: Artist Fred Wilson pulls apart Maryland's hidden history" in Globus, 31.

4 Fred Wilson in K. Anthony Appiah, *Fred Wilson: A Conversation with K. Anthony Appiah,* exh. cat. (New York: PaceWildenstein, 2006), 12.

5 Sean O'Toole, "Counting Bodies: It's not just about the maths," *ContemporaryAnd,* May 24, 2017, http://www.contemporaryand. com/magazines/counting-bodies-its-not-just-about-the-maths/.

6 See: Character Analysis *Othello,* Cliffs Notes, https://www. cliffsnotes.com/literature/o/othello/character-analysis/othello.

7 O'Toole.

8 Fred Wilson, interview with the author, December 19, 2017.

9 Ehud R. Toledano, "Ottoman Concepts of Slavery in the Period of Reform, 1830s–1880s," in *Breaking the Chains: Slavery, Bondage and Emancipation in Modern Africa and Asia,* ed. Martin A. Klein (Madison: University of Wisconsin Press, 1993), 39.

10 *Arap Kızı Camdan Bakıyor/The Arab Girl Looks Out of the Window,* a work produced and directed by Gül Muyan based on the three-generation story of marble master Mustafa Olpak that began in Africa and ended in İzmir via Crete and Istanbul. The quote is from the interview with Toledano in this work; https:// www.youtube.com/watch?v=1OY6mK9PO0Q.

11 Toledano, 39.

12 Dr. Hakan Erdem, *Çerkesler ve Kölelik (Circassians and Slavery)* http://www.gusips.net/analysis/interview/7823-dr-hakan-erdem-ile-soylesi-cerkesler-bir-nevi-nufus-satiyor.html. Erdem also shares significant academic findings in the field in his book *Osmanlıda Köleliğin Sonu 1800–1909 (The End of Slavery in the Ottoman Empire, 1800–1909).*

13 The Culture and Solidarity Association of Africans in Turkey was founded in 2006 by Mustafa Olpak. The aims and principles of the association include "the solving of the economic, social, cultural and humane problems of Turkish citizens of African descent within the framework of the equality of rights, with respect to the human rights and basic freedoms of all, and in view of domestic and international principles of law, with no discrimination on the basis of race, gender, language or religion; and the sharing with

the public of all information, documents and visual materials obtained as a result of academic research with no restriction or reservation," http://www.afroturc.org.

14 Yıldız Yılmaz, interview with the author, December 29, 2017.

15 Gürel Tüzün, interview with the author, January 3, 2018.

16 Alev Karakartal, interview with the author, January 5, 2018.

17 Fred Wilson, interview with the author, December 19, 2017.

18 Kıbrıs R.B., ed., *Kesişen Dünyalar: Elçiler ve Ressamlar/Intersecting Worlds: Ambassadors and Painters*, exh. cat. (Istanbul: Pera Museum Publications, 2014), 103.

19 Works from the Pera Museum collection shown in Wilson's installation: *Kağıthane'de Cirit (Cirit in Kağıthane)*, Luigi Acquarone (from Antoine Ignace Melling), oil on canvas (1891); *Grand Bazaar*, Amadeo Preziosi, watercolor on paper (1867); *Silk Bazaar*, Amadeo Preziosi, watercolor on paper (1878); *Whirling Dervishes*, Amadeo Preziosi, colored lithographic print on paper (1857); *Letter*, Rudolf Ernst, watercolor on paper (c. 1880s).

20 Jennifer Gonzalez, "Against the Grain: The Artist as Conceptual Materialist," in *Fred Wilson: Objects and Installations 1979–2000*, ed. Maurice Berger, exh. cat. (Baltimore: Center for Art and Visual Culture, University of Maryland, 2001), 29.

21 Magdalena J. Zaborowska, *James Baldwin's Turkish Decade: Erotics of Exile* (Durham: Duke University Press, 2009), 28.

22 Ibid, 22.

23 For detailed information on the exhibition *Parabéns* by Leylâ Gediz, an artist from Istanbul, which also includes a video work inspired by an African sculpture she found in her home in Lisbon, where she moved last autumn, and prepared using Esmeray's photographs and music, see: https://www.leylagediz.com/parabéns-17/.

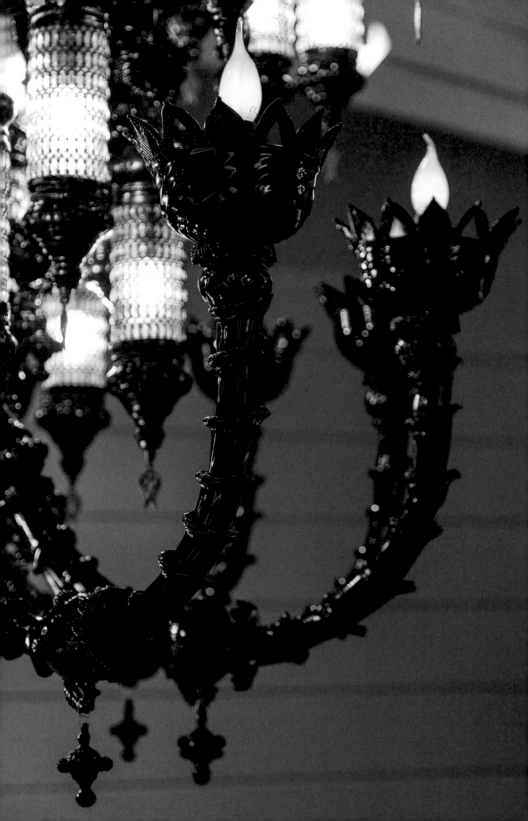

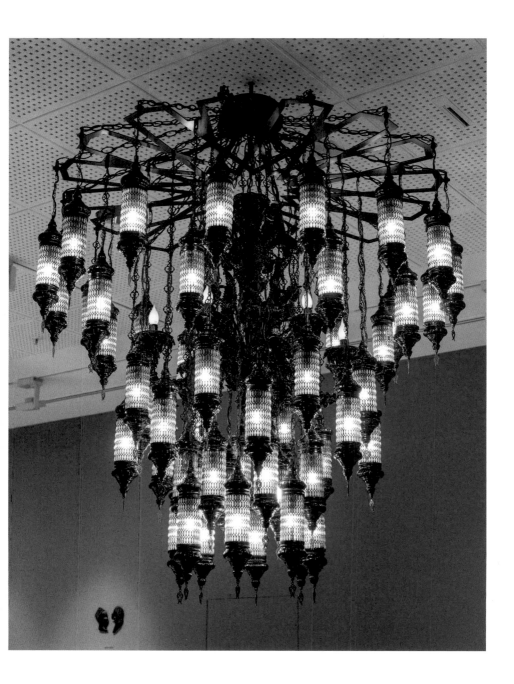

Fred Wilson Interviewed by Darryl Pinckney

DARRYL PINCKNEY What was your first encounter with the history of the Ottoman Empire? What got you interested in the black presence there? The first I ever heard of the Ottoman Empire, it was "the Sick Man of Europe." In the history class I am remembering, the Ottoman Empire at the start of the First World War had long been a stagnant society, a declining imperial world of chief eunuchs and harems.

FRED WILSON Well, Turkey has come a long way from that! Anyway, many countries in Europe were called that at one time or another. Tsar Nicholas conveniently coined the phrase when he (and other European countries) saw a weakness they could exploit.

Your history class was correct; however, it is good to note that the powerful Ottomans were a Muslim thorn in Christian Europe's side for centuries, even before their decline. Siding with Germany in the First World War certainly would not make American history

teachers warm up to them either. So, while our history classes were not necessarily wrong, their biases might have colored their perspective. Given America's slavery, followed by raging, systemic American racism during the time of the Ottoman's decline (and long, long after), America should have looked in its own backyard before calling somewhere else "the Sick Man." It would be interesting to see what the Ottoman history books on America were like. Would slavery, lynching, and Jim Crow loom large, as perhaps they might have in other countries' history books on America? Perhaps not. But it is interesting to think about.

I must admit, I never thought about the Ottoman Empire before creating my project for the Venice Biennale. My history class gave short shrift to the subject, or any subject other than Britain, Christian Europe, and the US.

I kind of backed into the topic. And as usual with my practice, when I have questions that go unanswered I go about trying to find the answers myself. It sets me on a path. Having visited Venice a number of times, I had always wondered who the black people were in the historical paintings in the museums there. In fact, when I was a child, long before I ever visited Venice, my mom had an art book on the coffee table in our home in which there was a painting by Tiepolo. It showed a black boy prominently standing by a canvas on an easel with the painter looking on. I asked my mother who the child was (as he was near my age at the time), but she did not know, of course. So, some forty years later, when I was researching the history of the Africans of Venice for the Biennale, it became clear to me that their presence had something to do, at least in part, with Turkey. While I was obsessed with the

Africans that inhabited not only the paintings but also other aspects of Venetian culture, I noticed that many of the sixteenth- and seventeenth-century paintings with Africans in the city scenes also had Turks in them. Since I was not focused on other foreigners in Venice (such as Turks, Jews, Germans, etc.), I did not look any deeper into it at that time. However, it did pique my curiosity. The paintings by Tiepolo, Veronese, and others depicted Turks, both as merchants and combatants—trading partners as well as the enemy. For those ignorant of the history of early Europe (like I was), it was hard to understand how they could be all these things, seemingly at once. Since my subject for the Biennale was the Africans, and I am not fluent in Italian and certainly can't read it, let alone decipher historic Italian documents, I let go of my interest in understanding the specific Turkish/African connection to the history and focused on the African presence. There were "Moorish" (African) doorknockers, jewelry, statuary, and even cookies (chocolate, of course), and still are. They inhabited the paintings of almost all the famous painters of the fifteenth, sixteenth, and seventeenth centuries. They were ubiquitous in Venice and no one could tell me anything about them. I was just left with, as an artist, the ability to imagine the Africans' lives: their desires, trials, and traumas. I just wanted them to be "seen," as they were invisible as living, breathing historical figures.

DP You said you had been reading Pushkin and thinking about his connection to Ottoman history. Have I got that wrong? What did you mean?

FW I have had an interest in Pushkin for quite a while now. Visiting Pushkin's home in St. Petersburg cemented the deal. His interest in his African great-grandfather

and, by extension, his own blackness and the African diaspora, endeared me to him. Before I went to Istanbul I was aware that Pushkin's great-grandfather Gannibal was stolen from his village in Cameroon when he was a boy, brought to Constantinople by Arab slave traders, and sold to Russian emissaries and given to Peter the Great as a gift. In Istanbul I found out who the sultan was who actually bought Gannibal, from whom the Russians stealthily took Gannibal, along with his brother and another youth, on the arduous journey back to Russia. From reading the tidbits in the various histories of this affair and Pushkin's own writing, I not only garnered a picture of Pushkin's illustrious relative, but also found out about the abduction of a black child in sixteenth-century Turkey. Reading Pushkin, where it relates to his interest in his heritage and "difference," was very important to my project. He was, like me, an outsider in Turkey (he actually visited Turkey once, though not Constantinople), and Turkish culture. It helped to have his perspective on his life and times, as I journeyed back in time.

I also read James Baldwin's *Another Country*, which was written, in part, in Istanbul. I have used texts from *Othello*, Pushkin, and Baldwin in my installation. It was just delicious that Baldwin, an African American visitor, was being his creative self in Istanbul—just like me. I placed quotes from *Another Country* above the Orientalist paintings. It is ironic that, while Baldwin escaped the American racial predicament by writing in Istanbul, and his writing had nothing to do with the historic African community in Turkey, some of the voices of the characters in *Another Country* seem to reveal the thoughts and desires of Afro Turks from earlier centuries. I just love that!

DP I never knew the real story of Gannibal. I listened to the historian Michael Ferguson on a radio program talk about Turkish history. I never knew of urban black enclaves in Salonica or communities of Greek-speaking, free black Muslims on Crete. You seem particularly interested in the Afro Turk presence in İzmir. Did they know themselves as Africans or Ottomans? The prints you include in the exhibition that expose the black figure while covering up others in the composition seem to ask these kinds of questions.

FW Wow! I must get that radio program! The difference between my Venice and Istanbul projects is that the black history in Venice does not lead to communities of contemporary black Italians with roots in the distant slave past. I met only one individual who told me that his ancestors were "Moors." Apparently it was the deep, dark secret of his family. Of course, you would not know it by looking at him. It is deep in his bloodline from the Renaissance. However, in Turkey, much to my surprise and pleasure, I was immediately told of the black community in İzmir. One sees Africans in Istanbul, but they are more likely recent immigrants from Africa. This, by the way, is one of the thorns in Afro Turks' sides. Turks are impressed that they speak fluent Turkish, assuming that they could not be from Turkey. To your point about African communities in Greece, at least one of the Afro Turks I met—a journalist—said that a more correct and inclusive term is "Afro Anatolian," because there are Afro Greeks, Afro Kurds, Afro Armenians, etcetera, all of whose ancestors were taken out of Africa by slave traders for the Ottomans centuries ago.

I wanted the sheer numbers of Afro Anatolians to be visible. I did not make it up. Art history is as culpable

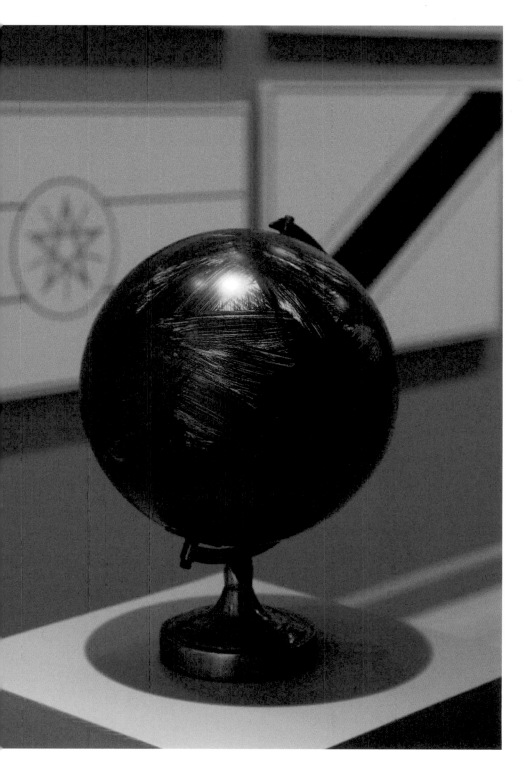

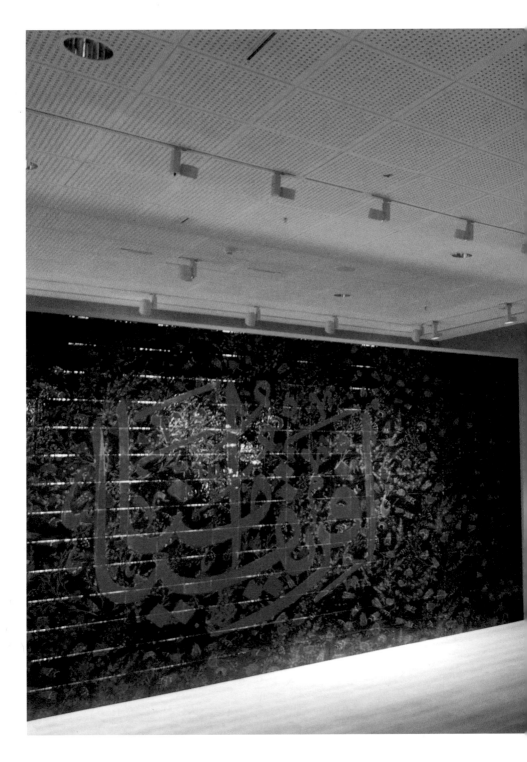

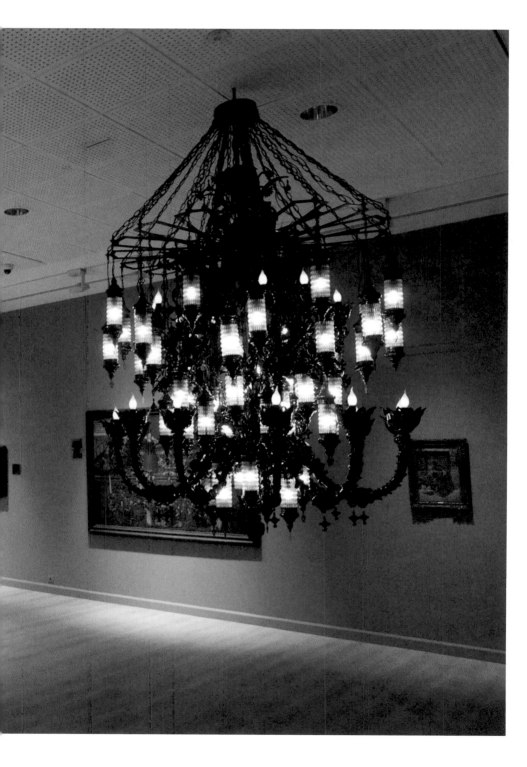

as any other biased historical or cultural record. Art history has focused on visual art and subjects, but has denied the reality of history. For a field that prides itself in the connoisseurship of "looking," they did a great job of not "seeing" what they did not want to see.

My work, such as the lithographs, seeks to shift the usual gaze to the unexpected, to what I cannot *not* see. In addition, there is a certain amount of aloneness or loneliness in these works. I have come to terms with the fact that it is "me" coming through. It is something I don't intend and I don't try to create, but those emotions are deep within me, rooted in my childhood. I never feel them now. However, I cannot keep them from coming back in my work again and again.

Yes, I do hope the lithograph works simply foster questions.

DP I have to say that it is an emotional experience in itself—getting to hear you talk about your work—to draw nearer to it in this way. Your installations have been described as meditations on the power of objects. They also reflect your sensitivity to objects, your deep interest in the histories of where they came from, how they were made, what their purpose was. This exhibition is about the making of things. How does that happen? Tell us about the chandeliers. What is the "melting mood"? Why are these "drops of tears"?

FW Ha! The "melting mood"—I like the *Othello* reference. In fact, *Othello* looms large in my world. Though *Othello* is fictional, Shakespeare tapped into an amazingly complex persona, one that rarely gets created with such an incisive yet poetic selection of words. At least this is true of an African character

created by a non-black writer, don't you think? My chandeliers have become a vehicle for embodying things that are as complex as Othello himself. Most are a meditation on death, on blackness, on beauty. The form of my chandeliers is of seventeenth-century Venetian design called Rezzonico. I have used the same style chandelier many times, with shifts in scale, color, and complexity, to express various meanings and emotions. My titles have been taken from lines in *Othello*, further tying the chandeliers to a historical moment, and the particular people and narratives within *Othello* become metaphors for my own thoughts and feelings. Inspired by the name of the Istanbul Biennale, *a good neighbour*, I thought to combine two chandeliers: the Venetian design and an Ottoman design. Simply, I wanted the chandeliers to embody the complex relationship between the Venetian Empire and the Ottoman Empire. When I create chandeliers, I do not think about whether they will be beautiful or not. I call them chandeliers, but they are really sculptures.

DP The great wall of tiles has enormous appeal to historical imagination. Is that part of the beauty of the objects?

FW I use beauty in the service of meaning. Beauty seduces you, lulls you, excites you, brings you in closer. Then when you are all warmed up and relaxed, I offer you something else to think about that may not be your cup of tea, that may be counter what you expected: the historical imagination, the "what ifs." My tiled walls are meant to be familiar, yet something is decidedly different. I used all the colors and patterns that are historically accurate but in combinations that are not "correct" to history. In fact, a well-meaning individual with a very long history of creating and

studying Ottoman tile was hell-bent on convincing me to change my concept—particularly my color palette and the use of traditional tile-painting technique—because he felt my colors would be too dark. He was sure that you would not be able to see anything. He was sure it would not look like what I intended it to look like, even though I had never said what I wanted it to look like. Clearly, what I wanted to do had never been done before. I thank Gokhan Aydemir of the İznik Çini Foundation for supporting me and my unusual concept 100 percent. Since my work was about Afro Turkish history, a shift in the visual represented a shift in meaning. The use of the beautiful Arabic calligraphy was intended to elicit memories within a Turkish environment, but also to be a shift in meaning, a shift in focus, and a shift in power.

DP The series of African flags rendered in black and white have figured in other works of yours.

FW Yes, as do the black glass "drips," as I call them. I decided to include the "flags" and "drips" because they change meaning in the context of Turkey and the subject of Afro Turks. The flag paintings (which are black paint on raw canvas—no white included) in other contexts perhaps are about the unfinished nature of nation building, among other things. But in this installation in Turkey, I feel the lack of color in the African flag paintings expresses a feeling of loss—the loss of the human potential in the wholesale theft and abuse of thousands of children and young adults abducted by slave traders. The drips always shift meaning, depending on the perspective of the viewer. Some see them as black tears, which would be appropriate in this context.

While you do see the colors in some of the younger generation of black artists' work, pan-Africanism seems to have vanished in African thought as well as African American thought. I am only aware of this through looking at the African flags. At some point, red, black, and green or red, green, and yellow stopped being used as an obligatory symbol of unity.

DP What does the windswept black globe stand for in this context?

FW The artwork is entitled *Trade Winds*. The "trade" in the title has nothing to do with its original meaning, which is "path" or "track." The trade I am referring to is the nefarious global trade in humans. Of course, by the eighteenth century the word shifted to mean "commerce," which, while referring to the winds of the Atlantic trade routes, is closer to what I was thinking about.

DP Your "black corner," if you don't mind my calling it that, is full of intrigue. What is the carpet?

FW The carpet is actually a contemporary carpet made from an old, traditional one. By removing the wool background areas and leaving the pattern, and then dyeing it with black dye, the color stays saturated only in the tufted areas of the pattern. I thought it was a perfect fit with my overall concept, mirroring the flag paintings.

DP I'd like to hear you talk about the seated wooden female figure placed inside the frame of the baroque chair and the beautiful birdcage and the window.

FW This whole environment was a culmination of my feelings about the historic Afro Turk presence in

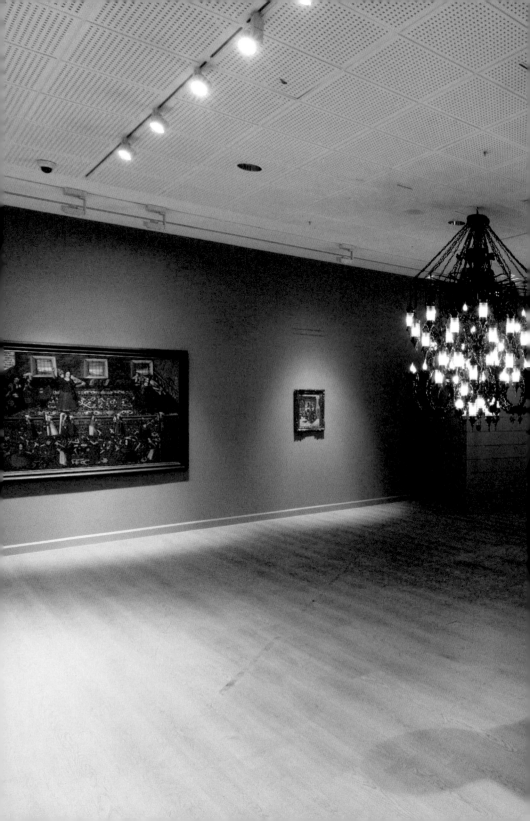

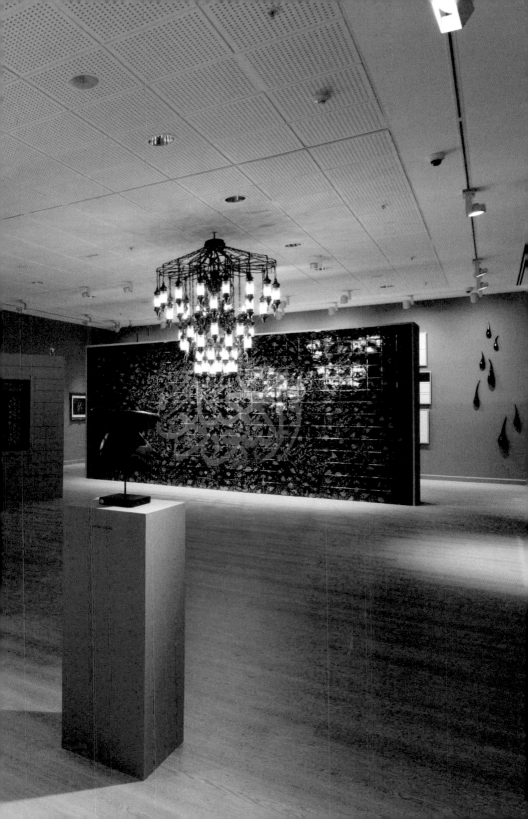

Turkey. It was not created with specific references in mind. After working on this subject over the year of visits to Istanbul, this image appeared as I collected the objects and put the corner together. It is as intuitive as I get. The window has two layers of decorative grates with two different patterns overlapped. I created the design from historic patterns of window grates that I saw in Istanbul. The birdcage was the first thing I saw outside of an antique/second-hand shop, on my first of many, many outings with my intrepid assistants. I liked it, but I left it. When I returned home to New York after that first trip (there would be seven trips in all)—without knowing what I would do with it—I realized I just *had* to have the birdcage. This particular one had a design on top that reminded me of a sultan's head garment. I called Istanbul immediately, a bit frantic, as I didn't want it to get sold out from under me (though it looked like it had been sitting there forever). Eventually, I sent the African figures from New York. Actually, I sent more than I needed because I did not know what I was going to do with them or how many or what type I would need. For this project they were raw materials from my studio that I just knew I would use. I'd like to leave it at that. Even the wooden structure that creates the room was dreamt up—I like to think of it as informed dreaming—from my experiences in Turkey, Turkish film, and historical research. The figure in the chair, the figure in the birdcage, the figure by the window, and the figure by the foot of the table—it is all guided by emotion. After it was lit, it felt right. That is all I can say.

DP How do the objects in this exhibition relate to your method of appropriation, reuse, and recombination of things?

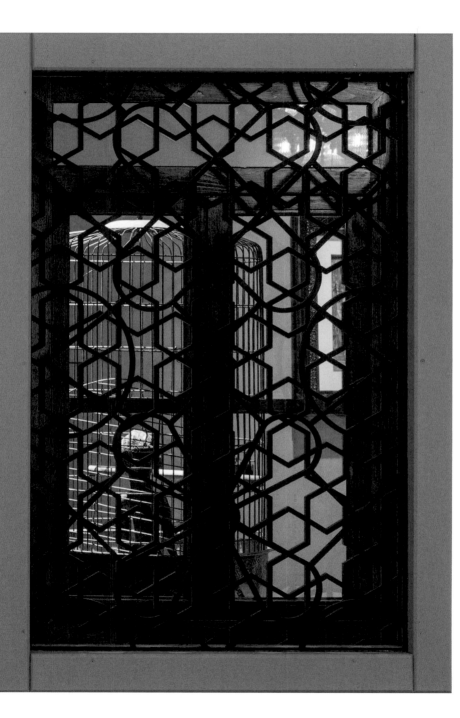

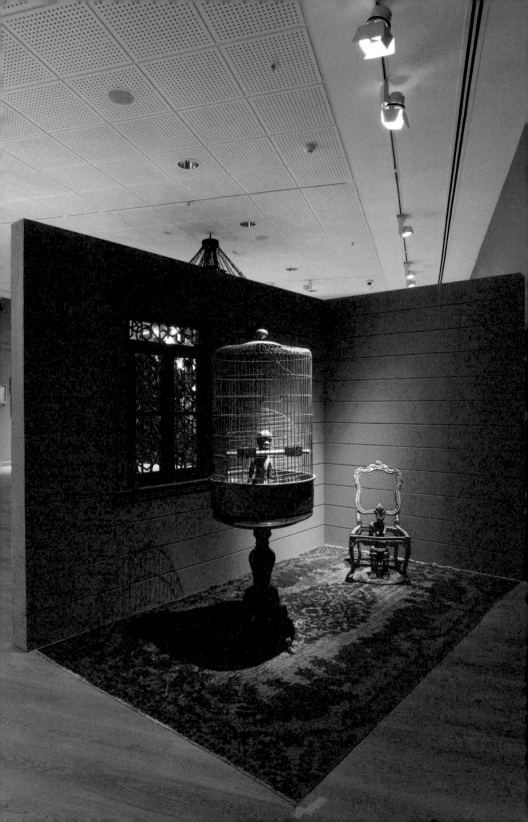

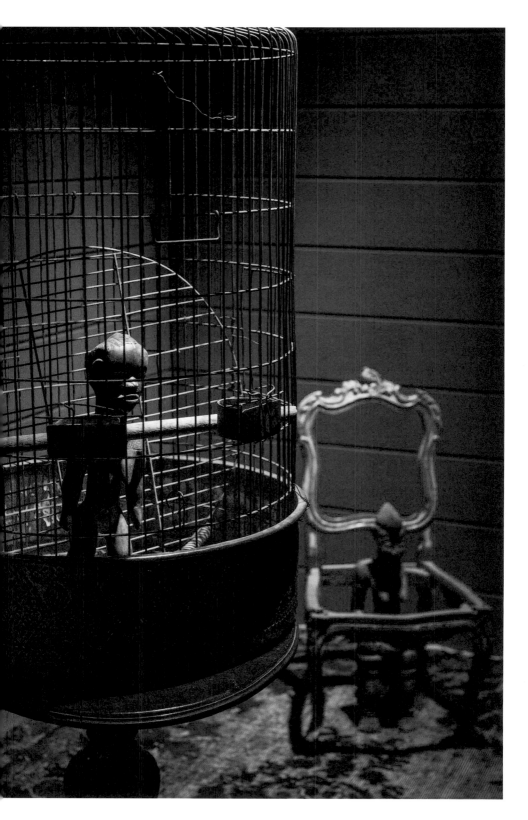

FW Oh, in many ways! I did not mention what the
tile walls' background colors were. One is aubergine
and the other is black. As I mentioned, both have
Arabic calligraphy written on them; the aubergine
wall translates to "Mother Africa" and the black wall
translation is "Black Is Beautiful." There were many
Orientalist paintings in the installation, since the Pera
Museum had a collection of them. However, in each
scene of the paintings I picked to include, there was
an African, an Afro Turk, sometimes in the margin,
sometimes depicted very prominently. The collections
manager famously found a few paintings in storage
with Africans in them, but I asked him if I could look
in painting storage as well. I found many more that
he had missed. This did not surprise me. I have done
this in a number of museums, and I always find more
than was initially found by the museum staff. No
one in museums is used to looking for, or seeing, the
black presence. This happened at The Metropolitan
Museum of Art not too long ago. I asked the staff to
list the paintings with images of Africans in them that
were on view in the galleries. They sent me a list of
the most obvious, "greatest hits," but of course I found
many more. So, in Istanbul, I felt I needed to heighten
their visibility. I made images of the Africans in these
particular paintings and put the facsimiles next to the
paintings throughout the exhibition.

Besides the African figures in the tableau, I included a
lovely Yoruba *Gelede* mask on a pedestal. The inclusion
of the mask was meant to link the Afro Anatolian
community to a true African ancestry that some of
the Afro Turks share. I specifically added a label with
the meaning and history of the mask and the Yoruba
people, so the Turkish public of all backgrounds could
experience an actual living African culture, which

is generally not on display in Turkey. African art can be found in object-crammed shops with vintage bric-a-brac, but not on display in museums. As the *Gelede* celebrates women—mothers, to be exact—I also added an image of an African woman onto the mask's pedestal, which I found in one of the Orientalist paintings, to further cement the relationship.

DP You once said that people go to a museum expecting history, but they come to a gallery "expecting the unexpected." In the current exhibition, you present us with beautiful objects. Does the current exhibition follow on from your Venice exhibition *Speak of Me As I Am* (2003)? There, you were concerned with the hidden history of Venice's Moors. Othello, the hired general in Catholic Venice, has status, visibility. But here you are thinking of blacks in the unknown East. Do you think that what it means to be black changes from place to place, period to period?

FW Yes, it certainly does follow on from my Venice project. In Venice I had Othello, an incredibly realistic, fictitious character, but no living black Venetians connected to that history. In Istanbul, I met with black individuals connected to the historic African population. I went to Turkey with a ton of questions about the Africans of Europe in the early centuries. I was looking to understand the relationship between Venice and Constantinople as well. I was very pleased to have found information on both subjects. Africans were spread around the countries of the Mediterranean and beyond, like New Year's Eve confetti—though you still have to tease out this history from the miniscule references buried in the indexes of tomes about the Middle Ages, the Middle East, the Renaissance, the Enlightenment,

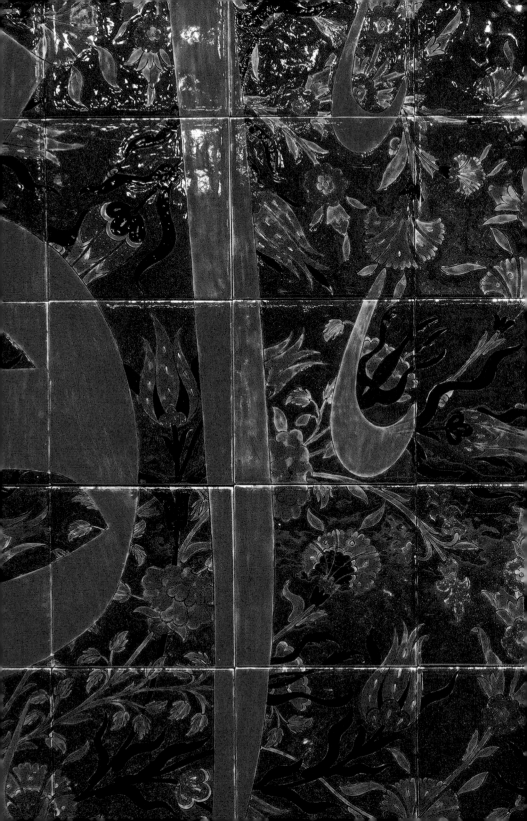

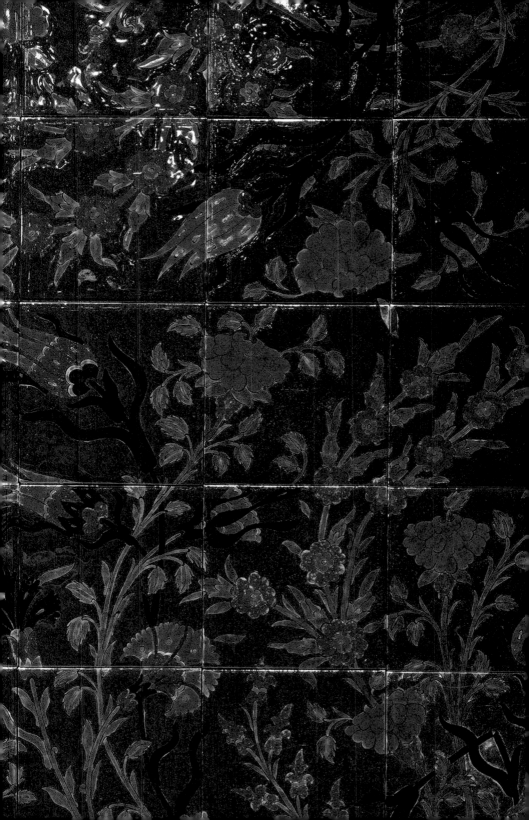

and Orientalism. It is amazing to me that it is only now that serious, focused scholarship is being done on this subject in both history and art history. I did find important scholarship on the powerful black eunuchs of the Ottoman Empire. But the larger history of the thousands of eight-year-old black boys "gelded" without anesthesia (only twenty percent survived the process) was more than I could stomach.

The fact of Gannibal, Pushkin's great-grandfather, made the historic black population even more alive. Thank you, Pushkin! You gave me hope and faith in the past. What I have to say about your question is, in my experience—and it would be nice to ask Skip Gates what he thinks about this—what it means to be black in the diaspora does not change from place to place. The contexts are different. Cultural differences of the former slave-holding nations have forced black folks to come to a black consciousness and pride at different points in time. I think where it can differ is in sub-Saharan Africa and African history where everyone is "black." Historically, the effect of slavery and the terms "slave," "slave trader," and "master" is more complicated and revolves around clan, tribe, religious belief, and social status—not skin color, per se. This has to have affected those relationships in different ways than those of us in the diaspora. Pan-Africanism was a major influence in its time, and I think the internet has really changed and accelerated a conversation about "blackness." However, African American history—US history, that is, and notions of race—is only one trajectory that has developed a very specific understanding of blackness. Speak to folks in the Caribbean and Latin America long enough and you might hear something slightly different.

DP Your work has a strong literary character, because of its relation to narrative and, especially, to black American history. Did you respond specifically to the brief, as set out by Elmgreen & Dragset—curators of the 15th Istanbul Biennial—that the title, *a good neighbour*, was intended to raise among artists "questions about ideas of home, neighborhood belonging, and coexistence from multiple perspectives"?

FW It was perfect. Considering the world today, the title could be understood sincerely or ironically. They had seen my work in Venice at the Biennale, and—*hallelujah!*—they remembered it all these years later. This theme could not have been better for me. I knew I was burning to better understand the relationship between Venice and Turkey in Ottoman times, and *Afro Kismet* has two areas that directly deal with that. There is a pairing of antique lithographs, one of Venice and one of Constantinople, where the boater in both is black. And the major works in the show, the chandeliers, reflect collaborative coexistence, both in form and in production. My eighteenth-century-Venetian-chandelier maker and my nineteenth-century-Ottoman-chandelier maker had to work together to create my vision. Conversations across the continent and across the internet in different languages occurred. And when the chandeliers arrived in Istanbul, it was incredible! Translations of Italian to English to Turkish to French to Venetian and back to English (for my sake), with all hands putting the artworks together. When the chandeliers were finally lit, no one language was needed. We all just cheered!

DP You have said that museums are themselves "cultural artifacts" in the West, and that they don't exist anywhere else. Except now they do. The Louvre is

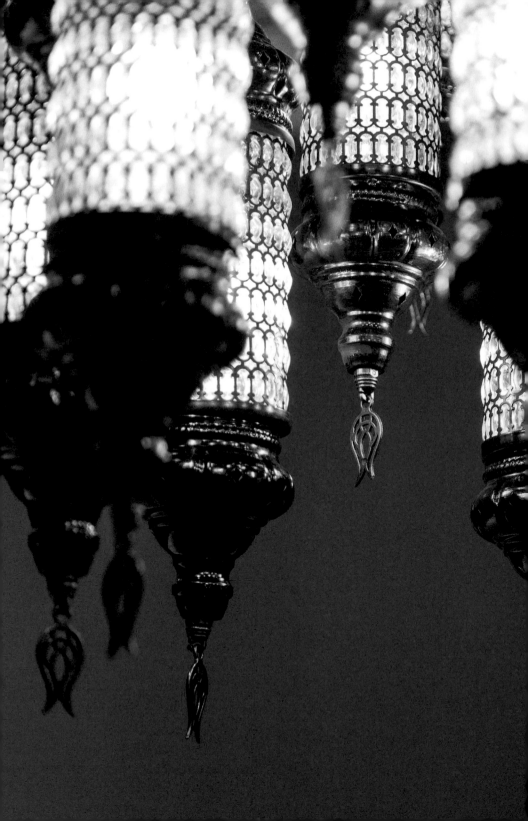

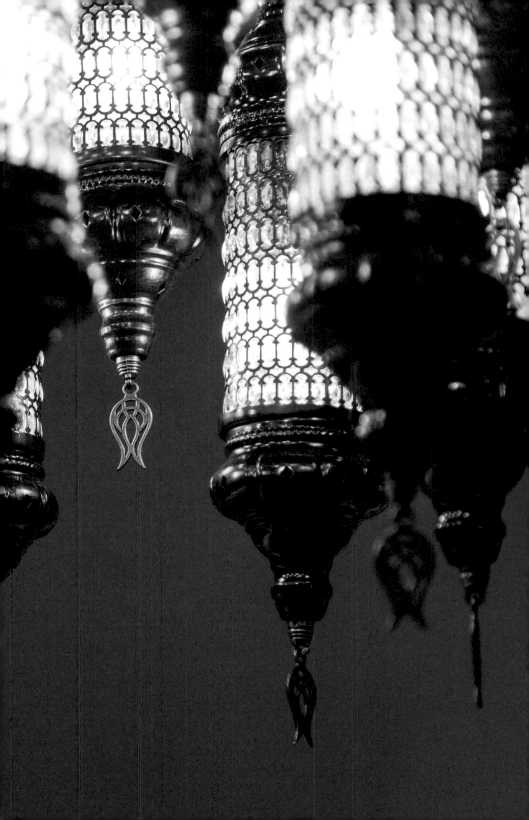

a franchise. Abu Dhabi is a site of cultural intersection. Or is it really? Museums are churches. Is that its new power in the visual age?

FW Gee, I must have said that a long time ago. The West created these things called "museums," and they are everywhere that they went. Now there are fabulous museums in places like Japan and Peru. With the newest places where museums are being planted—call it franchising, or buying museums—as with biennials, that has become a way for countries to raise their international profile and promote commerce. I would like to think that the commercialization of museums in countries that culturally and historically never had them is just the first step in engaging their public with art and ideas, to the point where the citizens can't imagine being without them. If they get there via artificial and less-than-altruistic means, so be it.

DP You once spoke of moving from place to place as a child. Does that background enable you to accept, or not be disturbed by, the transience of installation art, or to think differently about the randomness by which, over time, some art survives and most of it does not.

FW Perhaps moving had something to do with it. However, my museum works could not exist unless they were temporary. Museums want their galleries and their artworks for the next show. In most cases, I want the work to be temporary. My installations live on in the minds of those who see them. I do miss them when they are taken down, but I get over that and am excited to create the next one. Anyway, every artist has to deal with the idea that once an artwork is sold to a collector, you may never see it again. An installation is like a performance: Sometimes it can be repeated,

sometimes it can't. But even when it is repeated, it is never exactly the same. When I create a work without the knowledge of it being repeated, I am completely "in it" at the time of its creation. I change during the process of researching and conversing with people. The next time, the world is different, my experiences while recreating are different, and my memories are different. The work is different largely because I am not the same. I will be interested to see *Afro Kismet* in London, New York, and Charleston. I plan for it to be similar, but not the same as in Istanbul. How could it be? In my work, context is king. It will be as exciting if I can recreate it in the moment, so it has its own life and is not just a memory of itself.

Of course, I am also ready to create something fresh and new.

DP I have in notes from my first conversation with you the words "monstrous," "magnificent," and "mournful," but I neglected to write down what you were referring to.

FW Ahhh, I was talking about the first chandelier I made, for the Venice Biennale, called *Speak of Me As I Am* (which is the title of the exhibition itself). It was in the Venetian Rezzonico style. All the chandeliers are in white or pastel colors. Mine was big and black. I felt this chandelier embodied Othello himself: monstrous, magnificent, and mournful, all at the same time.

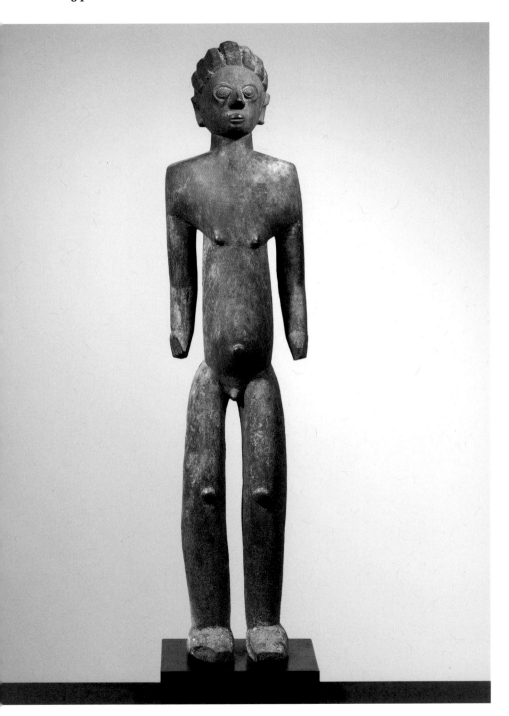

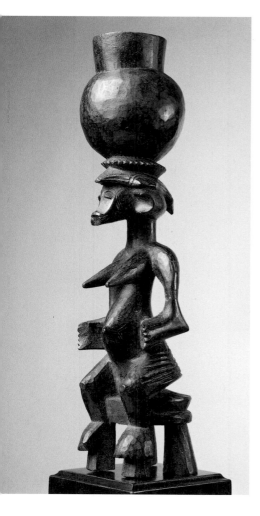

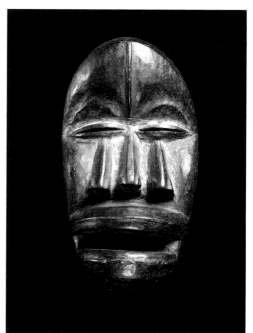

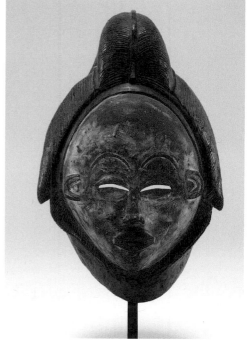

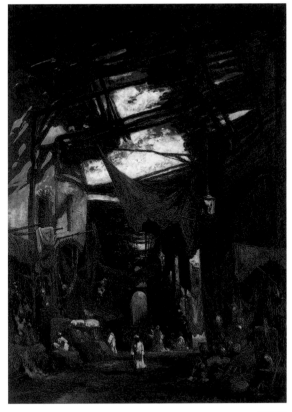

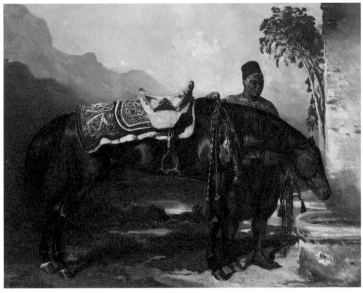

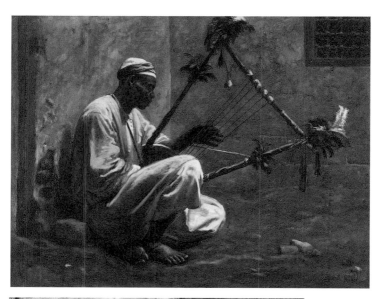

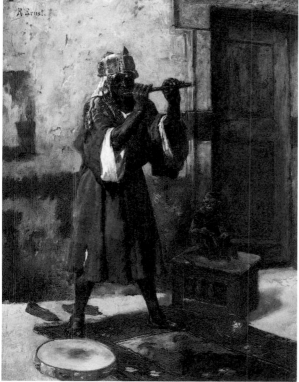

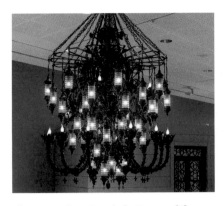

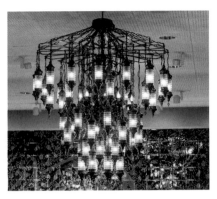

The Way the Moon's in Love with the Dark, 2017

Murano black glass, clear blown glass, brass, steel, light bulbs
78 ¾ x 55 ⅛ x 55 ⅛"
200 x 140 x 140 cm
AP 1 from an edition of 6 + 2 AP
Collection of Denver Art Museum purchased with funds from Contemporary Collectors Circle, 2017.207.

Edition 1 exhibited in London and New York

Eclipse, 2017

Murano black glass, clear blown glass, brass, steel, light bulbs
94 ½ x 55 ⅛ x 55 ⅛"
240 x 140 x 140 cm
AP 1 from an edition of 6 + 2 AP

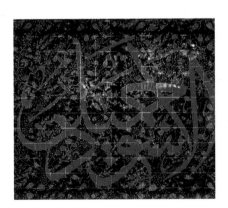

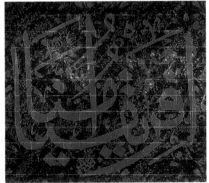

Black is Beautiful, 2017

Iznik tiles
9' 2 ¹³⁄₁₆" x 19' 2 ³⁄₁₆" x ⅜"
281.5 x 584.7 x 1 cm
AP 1 from an edition of 3 + 1 AP

Mother Africa, 2017

Iznik tiles
9' 2 ¹³⁄₁₆" x 19' 1 ¾" x ⅜"
281.5 x 583.6 x 1 cm
AP 1 from an edition of 3 + 1 AP

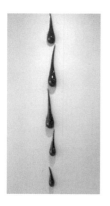 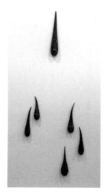 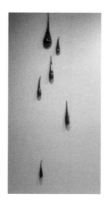 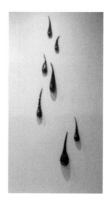

**Spill Spread
Splice Splurge
(A.G.),** 2017

blown glass
10' 2" x 6 ½" x 3 ½"
309.9 x 16.5 x 8.9 cm
approximate

**Spill Spread
Splice Splurge
(A.K.),** 2017

blown glass
81 x 29 ½ x 3 ½"
205.7 x 75 x 8.9 cm
approximate

**Spill Spread
Splice Splurge
(A.A.),** 2017

blown glass
9' x 28" x 3 ½"
274.3 x 71.1 x 8.9 cm
approximate

**Spill Spread
Splice Splurge
(A.T.),** 2017

blown glass
8' 7 ½" x 27" x 3 ½"
262.9 x 68.6 x 8.9 cm
approximate

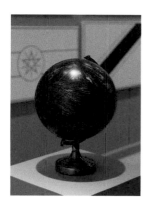 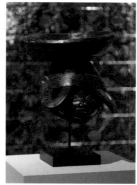 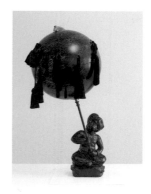

Trade Winds, 2017

plastic globe, die cast metal,
and acrylic paint
18 x 12 x 12"
45.7 x 30.5 x 30.5 cm

Gelede, 2017

Yoruba Gelede mask,
pedestal, digital print,
label, vinyl lettering
overall installation
dimensions variable

**Untitled (Zadib, Sokoto,
Tokolor, Samori, Veneto,
Zanzibar, Dhaka, Macao),**
2011

illuminated plastic globe,
acrylic paint, tassels, steel
armature, plaster figure, and
powder coated aluminum plate
28 x 20 x 20"
71.1 x 50.8 x 50.8 cm

They Passed Their Lives Thereafter in a Kind of Limbo of Denied and Unexamined Pain, 2017

6 framed engravings, 5 unframed engravings, vellum, vinyl lettering, poster, vitrine
overall installation dimensions variable

You Can't Forget Anything That Hurt So Badly, Went So Deep, and Changed the World Forever, 2017

7 framed engravings, 5 unframed engravings, vellum, vinyl lettering, cowry shells, vitrine
overall installation dimensions variable

DREAMS (The teeth of the world are sharp), 2017

4 framed miniatures, vinyl lettering
overall installation dimensions variable

The Juggler, 2017

framed miniature
16 ⅝ x 12 ¹³⁄₁₆"
42.2 x 32.5 cm

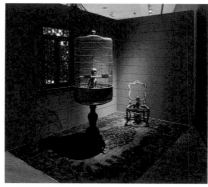

Nothing Ever Goes Away, 2017

5 framed engravings, vellum, unframed
photographs, vitrine
overall installation dimensions variable

Not in a Hurry, Like From One Day to the Next, but, Every Day, Every Day, For Years, For Generations, 2017

wooden walls, window, carpet, table, birdcage, chair, African sculptures
6' 5 ³⁄₁₆" x 3' 11 ¼" x 10' 2 ¹³⁄₁₆"
196.1 x 120 x 311.9 cm

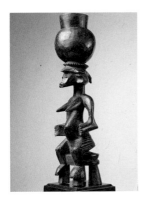

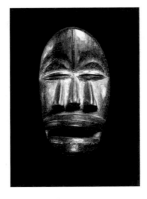

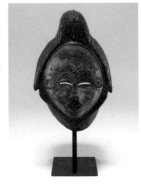

Senufo Seated Figure,
c. 1890, Ivory Coast
wood
16 ½ x 4 ½ x 4 ½"
41.9 x 11.4 x 11.4 cm,
overall

Dan Mask, c. 1890,
Ivory Coast
wood
16 x 5 ½ x 4 ½"
40.6 x 14 x 11.4 cm,
overall

Punu Mask, c. 1890,
Gabon
wood
16 ¼ x 7 ½ x 8"
41.3 x 19.1 x 20.3 cm,
overall

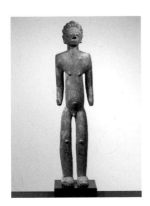

Lobi Figure, Bateba,
c. 1890, Burkina Faso
wood
36 ¾ x 8 ¾ x 8"
93.3 x 22.2 x 20.3 cm,
overall

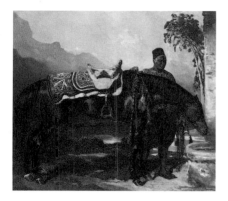

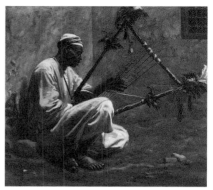

ALFRED DE DREUX

Hassan, Arab stallion with his haïk, 1858

oil on canvas
25 ¼ x 31 ½"
64 x 80 cm

FREDERICK GOODALL

Kissar player, 1859

oil on paper laid down on canvas
9 ⅝ x 12 ⅝"
24.5 x 32 cm

WILLIAM JAMES MUELLER

The Carpet Bazaar, Cairo, 1843

oil on board
22 ¹³/₁₆ x 16 ⅛"
58 x 41 cm

RUDOLF ERNST

The Musician, c. 1895

oil on panel
12 ⅝ x 9 ⅝"
32 x 24.5 cm

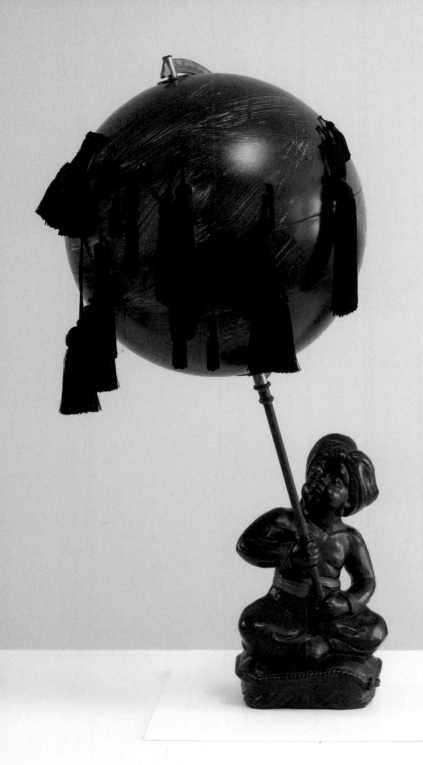

Catalogue © 2018 Pace Gallery
Works of art by Fred Wilson © 2018 Fred Wilson
Fred Wilson—Our Neighbor in Istanbul © 2018 Elmgreen & Dragset

Afro Kismet © 2018 Bige Örer
13,5, written by Sanar Yurdatapan and published by Pelikan Muzik;
essay and lyrics translated from Turkish by Nazım Hikmet Richard Dikbaş
Interview with Fred Wilson © 2018 Darryl Pinckney/Fred Wilson

Photography:
Brian Hastings; Front and back endpapers, pp. 25, 56, 72–73, 99 (top)
Thomas Hennocque, courtesy Galerie Ary Jan, Paris; pp. 96 (bottom), 97
Matthew Hollow, courtesy The Park Gallery, London; p. 96 (top)
Kerry Ryan McFate; p. 105
Pace African and Oceanic Art, New York; pp. 94–95
Poyraz Tutuncu; pp. 2–22, 26–55, 59–71, 78–91

Design: Tomo Makiura and Mine Suda
Production: Pace Gallery
Color correction: Motohiko Tokuta

Printing: Meridian Printing, East Greenwich, Rhode Island

Library of Congress Control Number: 2018936566
ISBN: 978-1-948701-02-0

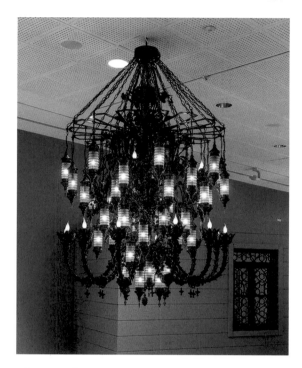

The Way the Moon's in Love with the Dark, 2017

Murano black glass, clear blown glass, brass, steel, light bulbs
78 ¾ x 55 ⅛ x 55 ⅛"
200 x 140 x 140 cm
AP 1 from an edition of 6 + 2 APs
Collection of Denver Art Museum purchased with funds from
Vicki and Kent Logan; Suzanne Farver and Clint Van Zee; Sharon and
Lanny Martin; Craig Ponzio; Ellen and Morris Susman; Devon Dikeou
and Fernando Troya; Baryn, Daniel and Jonathan Futa; Andrea and
William Hankinson; Amy Harmon; Arlene and Barry Hirschfeld; Lu
and Chris Law; Amanda J. Precourt; Judy and Ken Robins; Annalee and
Wagner Schorr; Judith Zee Steinberg and Paul Hoenmans; Tina Walls;
and Margaret and Glen Wood, 2017.207.

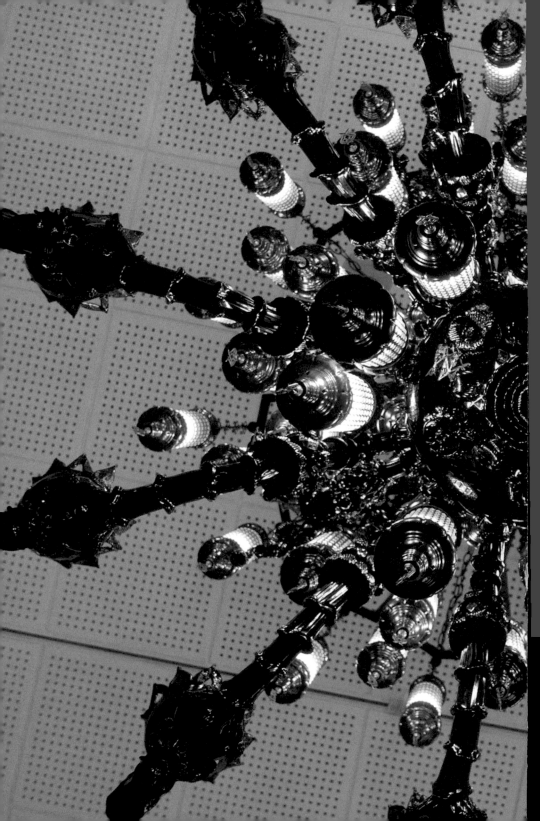